PORTRAITS FROM LIFE IN 29 STEPS

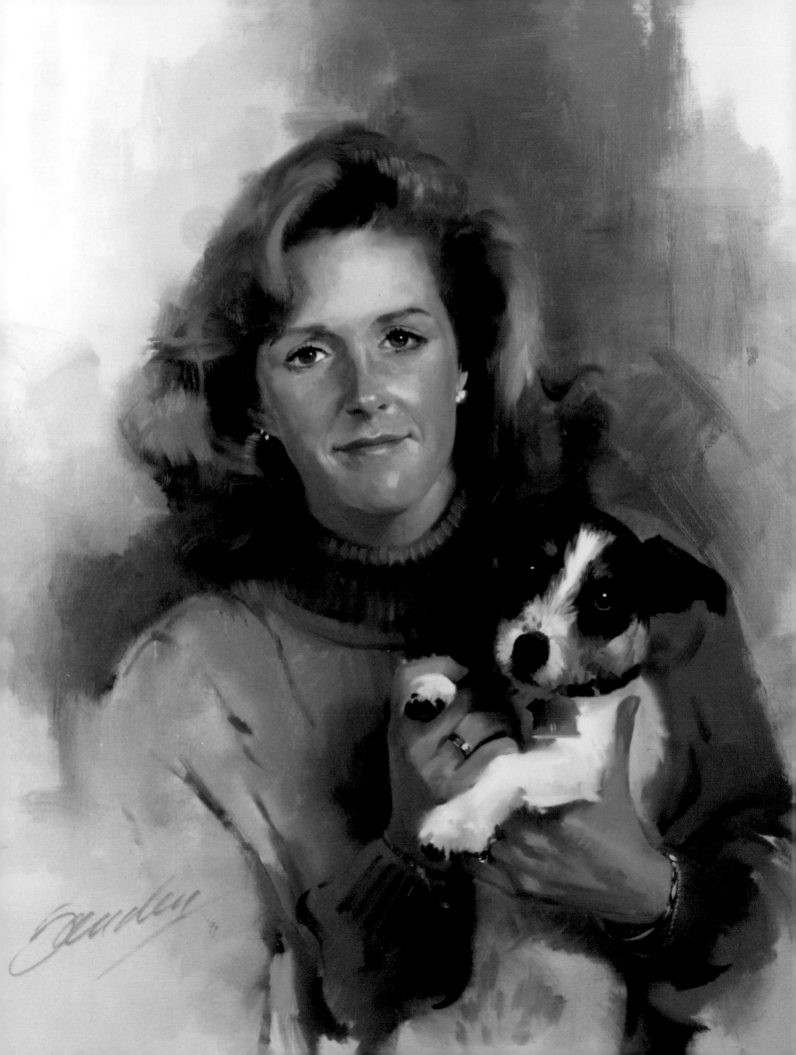

Portraits *from* LIFE
in 29 Steps

JOHN HOWARD SANDEN
with Elizabeth Sanden

NORTH LIGHT BOOKS
CINCINNATI, OHIO

A Word About the Paintings in This Book

The majority of the paintings in this book were painted as demonstrations before classes at the Art Students League of New York or the Portrait Institute. These demonstrations were presented within a constant time format: one hour and fifty minutes of painting time. You will also find, scattered throughout the pages, examples of commissioned portraits, each of which required many days to complete.

Demonstration study of a man with a gray mustache

Other fine North Light Books are available from your local bookstore, art supply store or direct from the publisher.

03 02 01 00 99 5 4 3 2 1

Library of Congress Cataloging-in-Publication Data

Sanden, John Howard.
 Portraits from life in 29 steps / by John Howard Sanden ; with Elizabeth Sanden.—1st ed.
 p. cm.
 Includes index.
 ISBN 0-89134-902-2 (alk. paper)
 1. Portrait painting—Technique. 2. Sanden, John Howard. I. Sanden, Elizabeth R. II. Title. III. Title: Portraits from life in 29 steps
ND1302.S25 1999
751.45′42—dc21 98-55424
 Rev.

Editor: Joyce Dolan
Production editors: Michelle Howry and Marilyn Daiker
Production coordinator: Kristen Heller
Cover designer: Wendy Dunning
Interior designer: Sandy Conopeotis Kent

Art facing title page:
Privately commissioned portrait,
oil on canvas, 26″ × 30″ (66cm × 76cm)

*To our daughter, Pamela,
her husband, Jason McMahon,
and our son, Jonathan
with our love and appreciation
for their support
and encouragement.*

Acknowledgments

We would like to express our appreciation

. . . to **Joe Singer**, who is a gifted and accomplished artist as well as a talented and disciplined writer.

. . . to **John Asaro**, who created the sculpture *Planes of the Head*, which appears on pages 30 through 33. John is a brilliant artist as well as a widely respected teacher.

. . . to **Connie and Gordon Wetmore**, for their friendship and encouragement over nearly three decades. Connie and Gordon live out their deep Christian faith in their daily lives, and are passing on their exemplary values to three beautiful daughters and countless people lucky enough to come into the wide Wetmore orbit.

. . . to **Basil Baylin**, our "oldest" friend in New York. Basil was monitor in the Samuel Oppenheim class at the Art Students League in New York so very many years ago, and has remained a loyal, steadfast friend and colleague ever since.

. . . to **Moria and Oldrich Teply**, for a thousand acts of friendship over the decades. Oldrich Teply is a phenomenally talented artist and a great teacher of art. He and Moira are superb role models to their large family, to Oldrich's students, and to all of us.

. . . to **Charles Schreiber** of the House of Heydenryk, New York, for his unfailing support with wise counsel and for hundreds of the most beautiful frames in the world.

. . . to **Tony Mysak**, master phoptographer, for his great assistance in photographing many of the paintings in this book, and for being a steadfast friend over the years.

. . . to **Ed Flax**, for his help and support in manufacturing the Pro Mix colors and keeping them available.

. . . to our loyal and hardworking agents: **Grayson** and **Jac Reville**, **Beverly McNeil**, **Ruth Reeves**, **Marian MacKinney**, **Winifred Gray**, **Phyllis Calisch**, **Pat Young** and **Francesca Anderson**, for their patience and faith.

. . . to the ladies of the **Community Bible Study** and the men of the **Men's Thursday Morning Bible Study**, both in Ridgefield, Connecticut, for their prayerful and gracious support and encouragement.

. . . and to **our gracious Lord**,
who walks with us through the days and nights
and shows us
the way home.

Table of Contents

Demonstration study of Dr. Arthur Melvin

Introduction

The purpose of this book is to present to you a simple but thorough procedure for painting a convincing portrait likeness in a single sitting, using twenty-nine logical steps. This 29-step method is the direct result of years of painting, demonstrating and teaching.

I commend the 29-step method to you. I hope you will give it a thorough trial. Perhaps you will end up with a less-structured approach. But I can guarantee the method described here has worked well for me and many other artists and will, at the least, be a wonderful disciplinary exercise for you as well.

The approach to painting you will find described in this book is a procedure called *alla prima* or *premier coup* painting. The idea is to strike at once for an immediate impression, to go directly for a final effect. This is one of the great historic traditions of painting. It is squarely within the framework of impressionism.

My painting methodology is based on training received from my mentor, Samuel Edmund Oppenheim, one of the great teachers of painting in America. His classes, conducted for many years in his private studio in New York and at the Art Students League, were always filled to capacity. His manner was courtly, gracious and gentlemanly, but he was a strong, purposeful and resolute teacher. He taught the art of seeing—of perceptive observation. "The model is the teacher in this class," he always said. "She says nothing, but she tells you everything." Oppenheim had no patience with esthetics or idle theory. His approach to painting was uncomplicated and direct.

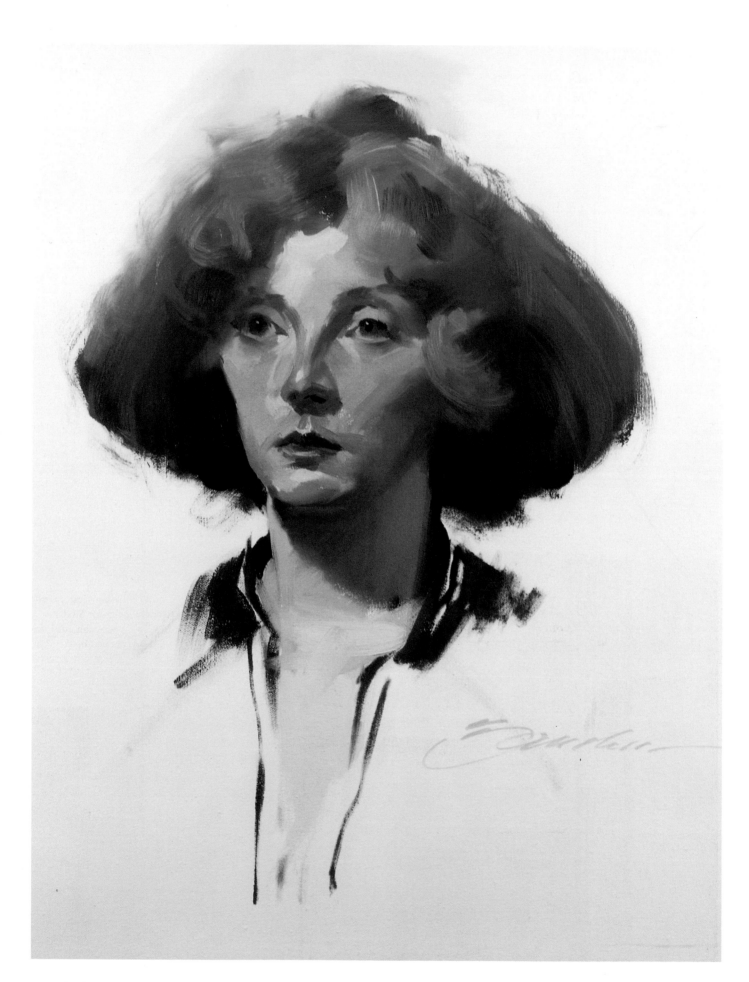

Be Truthful—Be Direct

My principal goals in painting can be summed up in two words: truthfulness and directness. As far as content is concerned, everything is based on observation. As far as method is concerned, it is *premier coup*: direct, calculated and purposeful. You'll find very little of esthetics or philosophy. The art of painting seems to me to be mainly an athletic undertaking, involving physical coordination between eye and hand. I've tried to be specific and unambiguous in writing about this art.

I've said that there is nothing more difficult or demanding than painting. It calls for a state of physical and mental alertness sustained throughout the session. There is no place for sluggishness. Every nerve must tingle. Every sense must be vibrating and sharp. Observe, analyze, respond with paint—all at white-hot speed. This is the painting act.

This is not a book on portraiture. It is a book on painting in which the subject matter just happens to be people. The real subject, after all, is light. What we really observe and paint is the effect of light as it falls across forms. This is why I consider myself an impressionist.

I hope you'll enjoy this book, and more importantly, I hope you'll enjoy the kind of painting it describes. For all his sober dedication, Mr. Oppenheim loved to say to us, "Don't be so serious about it!" He meant, I suppose, that, after all is said and done, painting must basically be a joyous act. Let the brushstrokes flow, he was saying. Let the colors sing.

—John Howard Sanden

SAMUEL EDMUND OPPENHEIM
American, 1901–1991

One of the most distinguished names in the history of American portrait painting, Oppenheim was an influential teacher at the Art Students League of New York, 1965–1973. His philosophy and techniques provided the basis for many of the teaching principles in this book.

J.H.S. with Emilie and Samuel Oppenheim, 1975.

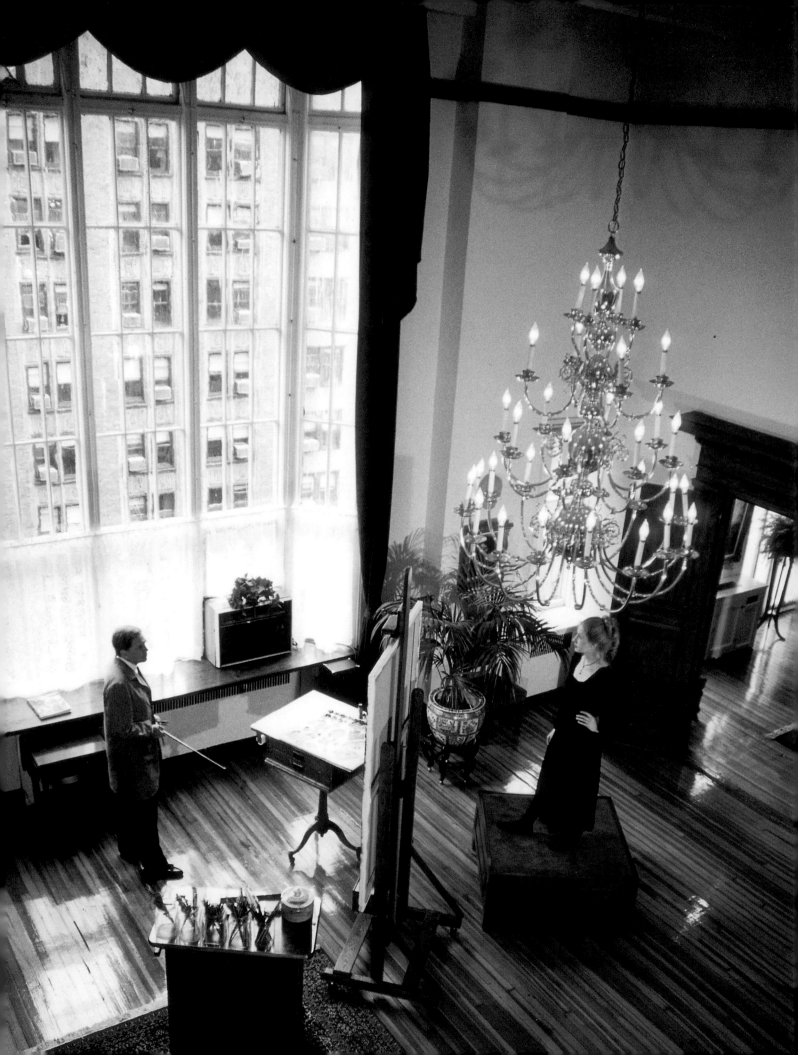

PART ONE

STUDIO ESSENTIALS AND SUPPLIES

Studio Essentials

I've worked in several studios over the years, both in New York City, where I have kept a studio for thirty years (see photo page 12), and in the country. For sheer comfort, this studio in my home in Connecticut is my favorite by far. It's very quiet, warm in the winter and cool in the summer, and you can't beat the commuting distance! The picture here shows the interior of my Connecticut studio. My wife, Elizabeth, is the sitter.

Booster Lights
Not seen in the picture is a bank of eight "daylight" fluorescent tubes, mounted in the ceiling, to provide working light for dull days.

Studio Dimensions
The main studio room measures 24′ (7.3m) square. The ceiling is 16′ (4.9m) high. In addition to the room pictured here, there are an office/reception room, two storage rooms and a bath.

Taboret
A movable stand sits near the easel to accommodate brushes and miscellaneous tools. See page 17 for a close-up of the brush washer.

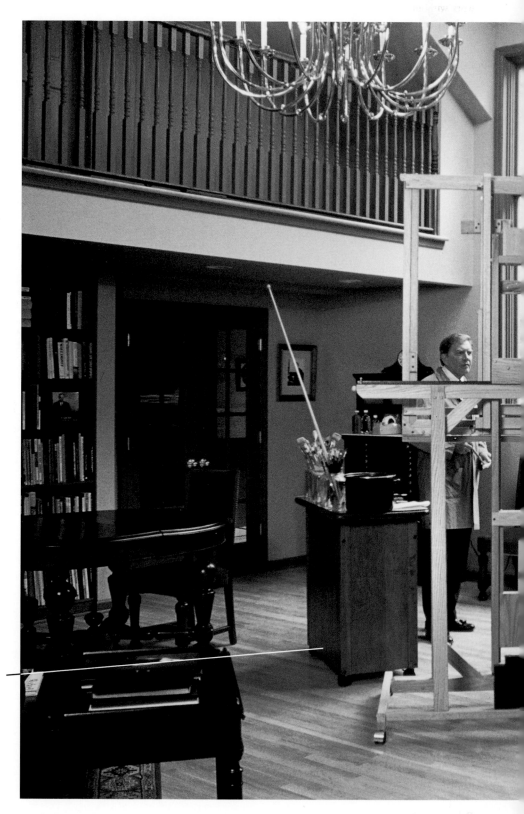

Studio Easel
The famous Hughes easel, shown in use here, has a counterbalance mechanism that allows for fingertip movement of the painting, both vertically and from side to side. How did I ever work without it?

Contact: Hughes Easels, Inc.
3315 South Tamiami Trail
Punta Gorda, FL 33950
(941) 637-8252

North Light
The window begins 4′ (1.2m) above the floor and rises to a height of 14′ (4.3m). It is 12½′ (3.8m) wide.

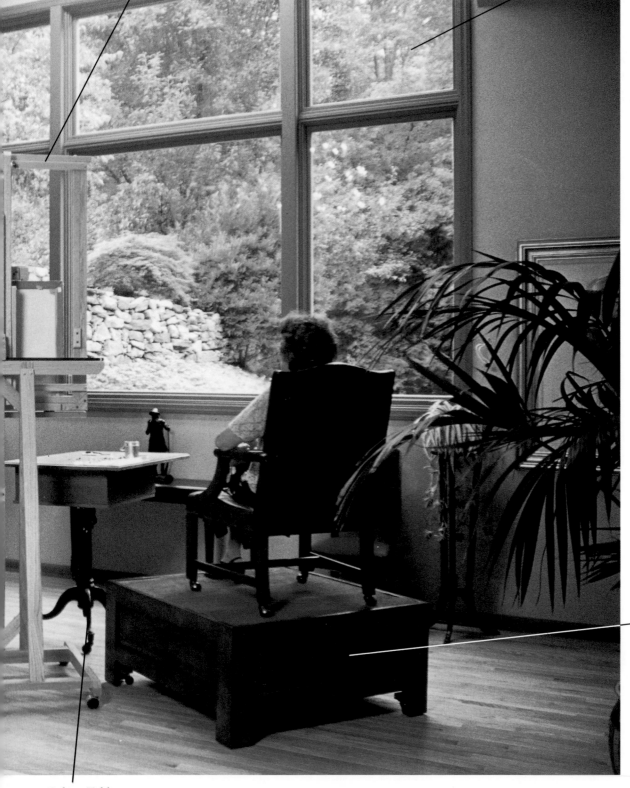

Model Stand
With a surface 48″ (1.2m) square and standing 18″ (46cm) high, the stand must be sturdy and rigid. Carpeting adds to the appearance and safety. A narrow lip of molding ensures that the chair will not slip off.

Palette Table
See page 18.

Brushes

A Recommendation on Artist's Brushes

For the past ten years, I have used and enthusiastically recommended the splendid line of brushes manufactured by Silver Brush, Ltd. of Princeton Junction, New Jersey. I'm convinced that they are the finest artist's brushes made today. At my request, Silver Brush makes available as a set the forty-eight brushes recommended here, calling the set the John Howard Sanden Professional Brush Collection. You may obtain this set by mail from The Portrait Institute, P.O. Box 600, Georgetown, CT 06829, (203) 438-0297.

Because my painting method dictates that the brush be as clean as possible for every stroke, I advise having a good supply of brushes on hand so a fresh one will always be available.

I also advocate placing a quantity of paint on the canvas and letting it stay there rather than blending, scumbling or otherwise "sloshing it about," so it's vital that you're able to select the right brush for the particular passage you're painting. The width of the brush must fit the area to be covered as closely as possible, and the only way you can manage this is if you're free to reach for the right brush without a moment's hesitation.

Therefore, (1) collect as many brushes from the list below as you can afford; and (2) get to know each brush well so you can reach for the right one at the right time as instinctively as you reach for your toothbrush in the morning. Incidentally, brushes—even when they're the same size and the same category—tend to develop their own individuality, so they differ in character from their identical twins.

As your brushes grow old, frazzled, skimpy or otherwise useless, discard them without a moment's hesitation and replace them with nice, fresh new ones.

I use five kinds of brushes:

I suggest that you have four each of the following sizes of Grand Prix bristle filberts from Silver Brush, Ltd.: nos. 2, 4, 6, 8, 10 and 12.

Bristle Filberts

The majority of my work is done with the bristle filbert, which is not—as one may suppose—a nut, but a kind of compromise between a flat and a round brush. The brush is somewhat long and flat with rounded corners. I find this shape particularly useful because it gives me control over the stroke: It doesn't produce the sharp edge imposed by a flat brush, nor does it feather, and it allows me to vary the width of the brushstroke. I also find it easy to make a knife-edge stroke with a filbert if I so desire. All in all, it's my main all-around painting tool.

I recommend two of each of these Silverstone bristle fan blenders from Silver Brush: nos. 2, 4 and 6.

Bristle Fan Blenders

This brush resembles a peacock's tail in full courting display. I use it sparingly to drag a quantity of paint into an adjoining area without disturbing the strokes. It can also be used to directly paint such smooth, flowing objects as hair, fur and other soft materials. Due to the weak, indistinct quality of its bristles, use the fan blender sparingly lest it render a passage too superficial and "pretty."

I recommend two each of Silver Brush's Renaissance sable brights, nos. 2, 4 and 6.

Sable Brights

I use these brushes to paint occasional fine details difficult to achieve with the other brushes. The Renaissance sable bright from Silver Brush is a wonderfully flexible and expressive instrument.

Buy two each of Renaissance sable rounds, nos. 6, 8 and 12.

Sable Rounds

Use the no. 6 sable round to put the highlights (also called the catch lights) in the eye and to blend small passages in the face.

One each of Renaissance sable "cat's tongue" brushes, nos. 4, 6, 8, 10 and 12, will give you the experience of enjoying these excellent brushes.

Sable "Cat's Tongues"

The so-called "cat's tongue" brush was developed by Silver Brush, and you will not find anything like it elsewhere. The unique shape of this brush, plus its springy vitality, makes it a delight to use.

A Keep-Wet Tray for Your Brushes

I use a roasting pan half filled with mineral spirits to store bristle brushes overnight. The brushes rest on a roasting rack submerged in the liquid. A piece of clothes hanger wire has been fashioned to elevate the wooden handles out of the solvent.

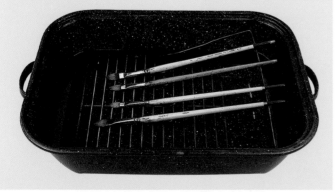

Heavy-Duty Brush Washer

Component parts from the cooking utensils department combine to make a heavy-duty brush washer. The circular rack lies submerged in mineral spirits. Rubbing the brush against the rack releases the paint from the brush, and it falls to the bottom of the pan.

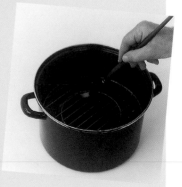

The Palette

My studio palette is a plate of ¼"-thick (64mm) clear glass measuring 27" × 36" (69cm × 91cm) in diameter. The top of the palette table is painted white. A palette this size provides sufficient space to accommodate a constant flow of fresh decisions during the painting session. Since I mix just enough paint at one time for a single brushstroke, many mixtures result and a big mixing area is in order.

I use clear glass for my palette for two reasons. First, the white surface below the glass allows me to mix my paints against the tone that I find most congenial. Since I usually paint on untoned canvas, I can accurately estimate how the mixture will appear on the white surface. Second, the glass is easy to scrape and wipe clean.

The palette rests on an old cast-iron drawing table that's set on casters. It's exactly 39" (1m) high, which is just right for me in my customary painting position (standing). When I'm painting, I always keep the palette on the same side of me as the model. I try to see to it that the light hitting the model and the light hitting the palette is approximately the same value and intensity.

That long stick resting on the palette is my "mahlstick," a rounded piece of wood about 4' (1.2m) long. I hold it in my left hand, resting the rounded tip against the canvas or the edge of the canvas while resting my right hand on the stick for steadiness when painting detail. The oblong piece of wood with brushes on it is my brush holder, which is made of molding mitred at the corners. The two long sections are notched to keep the wet brushes from rolling off. The upper drawer holds tubes of standard colors. The lower drawer holds Pro Mix colors. The small stainless steel container is a traditional artist's brush washer, which I use mainly as a dipper. I use only mineral spirits to thin my colors or to make them flow. The roll of paper towels must be Bounty brand—no other brand works as well.

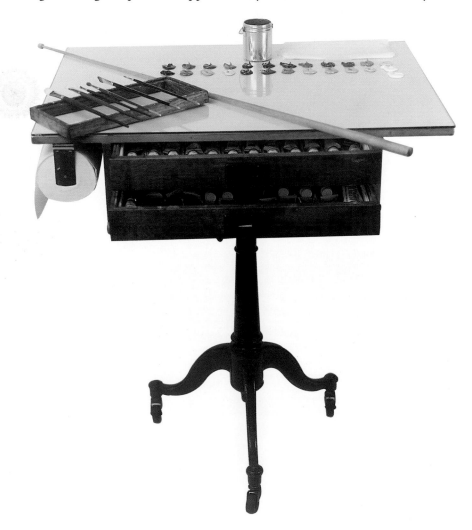

Painting Supplies

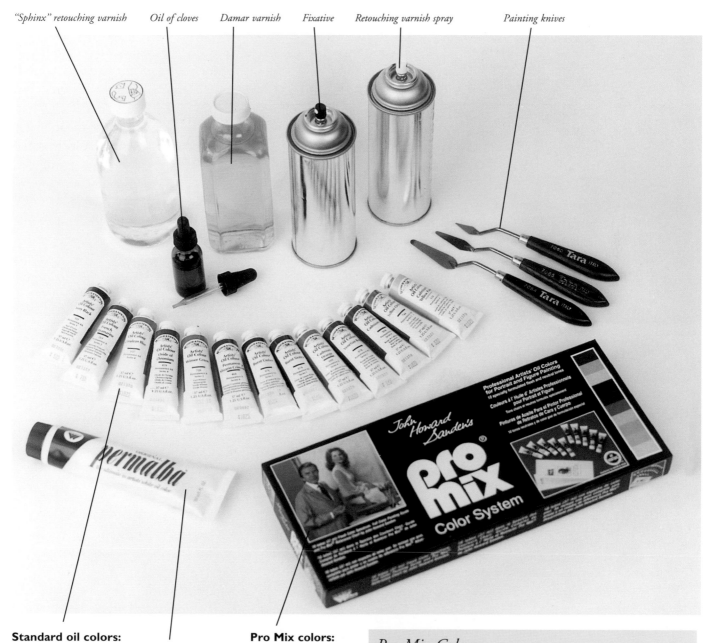

"Sphinx" retouching varnish Oil of cloves Damar varnish Fixative Retouching varnish spray Painting knives

Standard oil colors: Permalba White Pro Mix colors:

Standard oil colors:
Cadmium Yellow Light
Yellow Ochre
Cadmium Red Light
Venetian Red
Cadmium Orange
Burnt Sienna
Burnt Umber
Alizarin Crimson
Chromium Oxide Green
Viridian
Cerulean Blue
Ultramarine Blue
Ivory Black

Pro Mix colors:
Light 1
Light 2
Light 3
Halftone 1
Halftone 2
Dark 1
Dark 2
Neutral 3
Neutral 5
Neutral 7

Pro Mix Colors

An explanation for the use of Pro Mix begins on page 38. John Howard Sanden's Pro Mix Color System is manufactured by the Martin/F. Weber Company of Philadelphia and should be available at your local art materials dealer. Or you may contact The Portrait Institute, P.O. Box 600, Georgetown, CT 06829, (203) 438-0297.

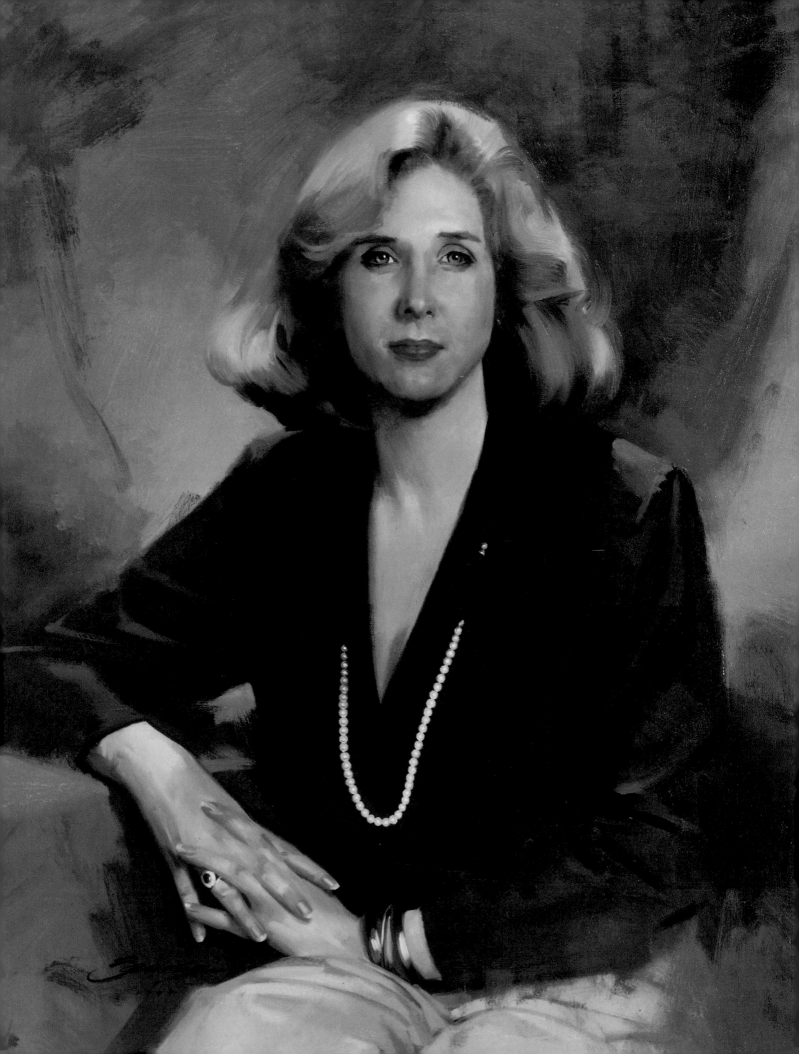

PART TWO

THE ELEMENTS OF PAINTING

Drawing • Values • Color

Drawing

I don't differentiate between drawing and painting. To me, these are part of the same process. Each time I place a brushstroke I am in fact painting and drawing. The preliminary marks I use to begin a painting of the head are like a map rather than a full-scale drawing. I advise against a full-scale drawing in preparing a portrait not only because it's quickly obliterated, but also because it's too confining. A full-scale preliminary drawing involves a commitment, and you should be free to change the painting as it progresses.

Don't Sacrifice Position

Once you divide drawing and painting into two disparate functions, you may be tempted to forget position and concentrate only on the value, hue and intensity. Position is the most important element, guiding every stroke you place on the canvas! If you paint a head in which the position of the strokes is absolutely right, even though the values and colors are somewhat off, you'll still come up with a passable portrait. Sacrifice position, however, and you're doomed to failure.

Position means drawing. Each time you place a brushstroke, you're not painting but in fact modeling the form or, if you like, drawing. Drawing is position, placement, modeling—all factors that are present each time you apply a brush to canvas. I use pure line only in the very first strokes that I quickly lay in to guide my subsequent steps.

Four Factors

There are no shortcuts, mysterious schemes, involved diagrams, complex anatomy charts or secret formulas to achieve good drawing. The main ingredients are observation and selection. Or to put it simply, good drawing requires the ability to see, to reduce the great sum of information taken in by the eye from a very complicated to a very simplified form and, finally, to put it all down on paper or canvas.

To give some formal substance to these two processes of observation and reduction or selection, I've worked out four factors to consider when contemplating the position for a brushful of paint—in other words, when drawing. The four factors are angles, mapping and proportion (or relative distances), plumbing, and positive and negative shapes.

An Observation

Painting with the brush is the most sophisticated kind of drawing because you're simultaneously turning the planes of the face, making objects seem to recede or advance, and getting the dimensions just so. It's impossible to place a brushstroke of paint on the canvas without being involved in a drawing decision.

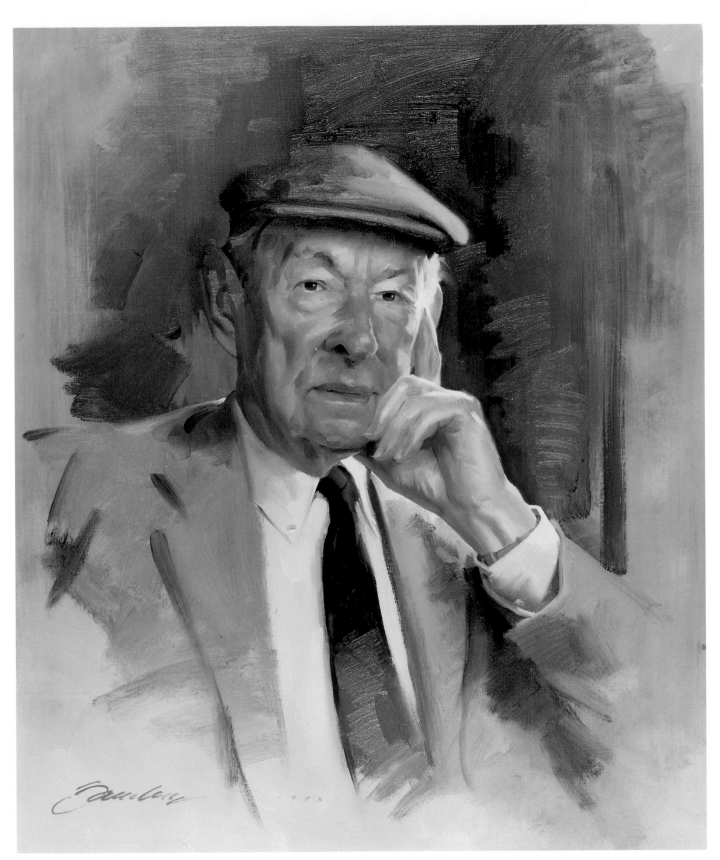

HERBERT WARREN WIND
Oil on canvas, 24" × 20" (61cm × 51cm)
Collection, United States Professional Golf Association

Conceptual Aids to Drawing

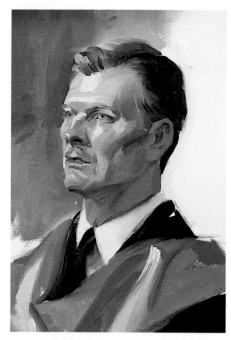

Reference drawing

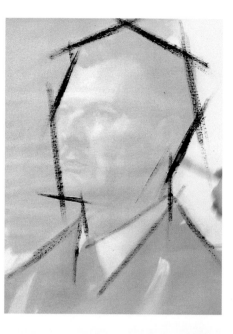

Angles

Drawing in angles is a process of reduction. For example, rather than slavishly following the contours of hair, with its dozens of possible dips and swells, you reduce the entire mass to two or three straight angles that follow the general direction of the hair. Through this radical simplification you end up with no more than three or four horizontal, vertical or diagonal places representing twenty, thirty or more short, straight, angular or curved lines.

This process of reduction allows you to master a bewildering array of conflicting and confusing minor details that might drive you to distraction if you tried to capture every tiny dip, bump and hollow. Once you learn to see in angles, the complicated mass before you will assume such obvious, dominant, significant angles that every brushstroke you lay from then on will follow a definite direction.

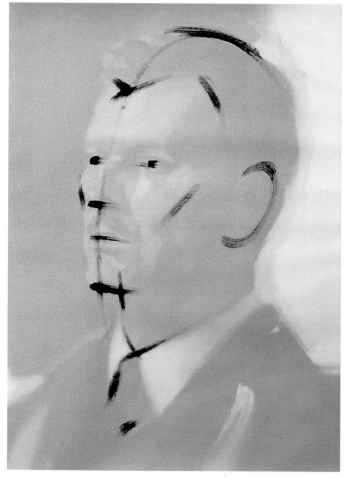

Mapping and Proportions, or Relative Distances

When considering the proportions of the subject before you, it's vital to establish a map that indicates the relative distances and relationships between points of importance on this form and to mark them accordingly.

In this process, all esthetic considerations are put aside for the sake of sheer accuracy. In other words, if the subject is the head, where does the corner of the left eye lie in relation to the edge of the nostril, or to the corner of the mouth, or to the Adam's apple, etc.?

If enough landmarks are simply but accurately stated throughout the painting, every feature and plane on the picture emerges correctly because each is right as to size and position in relation to all the other features in the portrait.

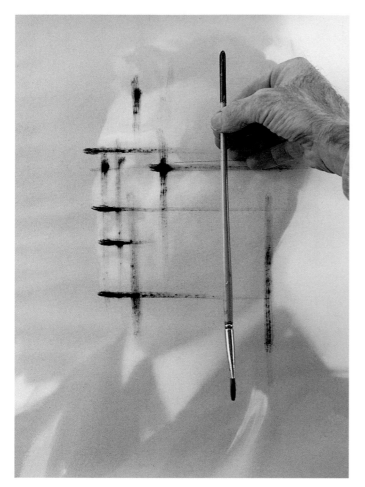

Plumbing

A plumb line is simply a string tied to a weight. When the weight dangles freely, gravity pulls the string to an accurate vertical line. The plumb line is one of the finest means of establishing the landmarks we've discussed, since it reveals precisely what lies directly on a straight line with something else.

You can work with an actual plumb line, but holding a plumb line while painting seems clumsy and mechanical. I suggest the mental use of this device or using a brush handle until your eye becomes trained to do this automatically. The plumb line can be used vertically and horizontally. By extending such a straight line up and down or from side to side and following it from end to end, you can observe which of the landmarks fall directly upon it.

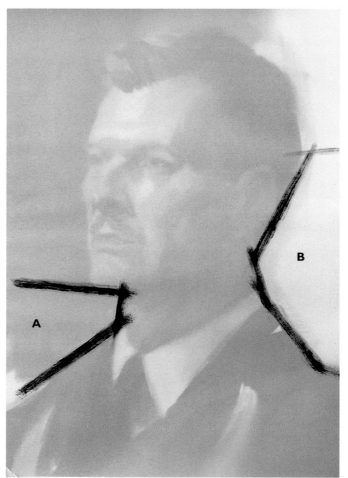

Positive and Negative Shapes

An excellent method of checking the accuracy of a drawing is to reverse the usual order of seeing and shift your focus from the positive to the negative shape. In this way, you can observe and put down the negative shape on the canvas (it's usually a much simpler shape) and be assured that the positive shape will then emerge in accurate contour and proportion.

In this example, the negative space A, created by chin, neck and shoulder, aids in drawing the length of the neck and the slope of the shoulder. Incidentally, most students draw the neck too long because they concentrate their attention on the chin and neck and fail to note the actual length of the negative shape that exists there. The negative space B aids in determining the shape of the head and its attitude on the shoulders.

Draw the Head

Drawing the head can be a simple procedure if you follow a definite plan based on the aforementioned principles. This demonstration shows how to go about it.

Reference drawing

STEP 1

Use a no. 4 bristle filbert dipped in Neutral 5, and make a mark to indicate the uppermost point on the hair, at a point about 2½" (6.4cm) down from the top of the canvas.

STEP 2

The second mark indicates the bottom of the chin. These two marks should be 9½" to 10" (24cm to 25cm) apart, making the head fully lifesize.

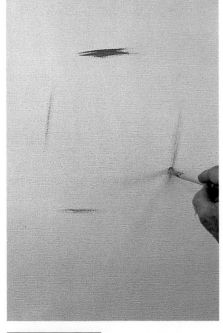

STEP 3

The third and fourth marks indicate the horizontal limits of the head. I have now placed four marks on the canvas and, in so doing, established the size and placement of the head.

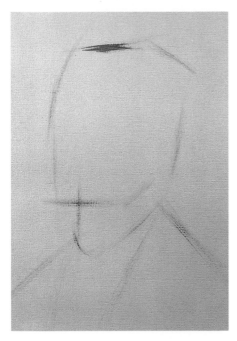

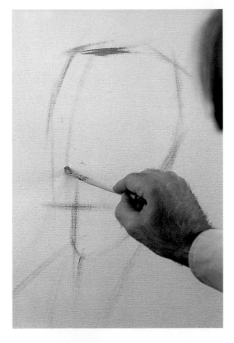

Indicate the column of the neck and the slope of the shoulders. Using additional strokes, block in the basic shape of the head as silhouetted against the background.

STEP 5

Establish the vertical axis of the face with a single curving stroke.

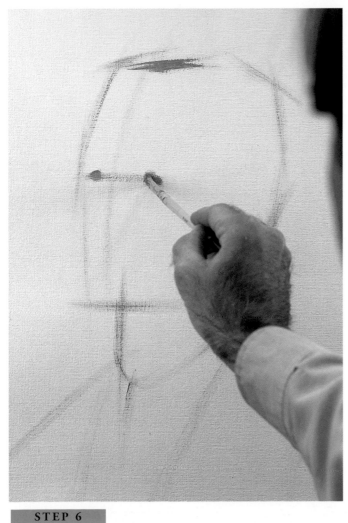

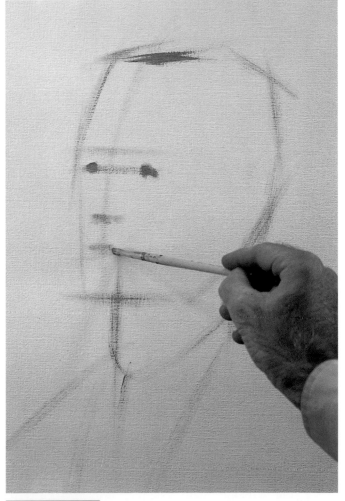

STEP 6

Now begin to "map" the landmarks of the face. At the vertical midpoint of the head, place a horizontal axis for the eyes. Indicate the position of the irises.

STEP 7

One mark indicates the base of the nose and another the division between the lips. Provide a horizontal axis for the eyebrows.

STEP 8

Locate the cheekbones. Here I'm beginning to show the "corner" of the face, that is, where the light and shade meet.

STEP 9

Locate the ear, relating it to the face. The angle of the jaw is indicated, as well as the hairline above the forehead.

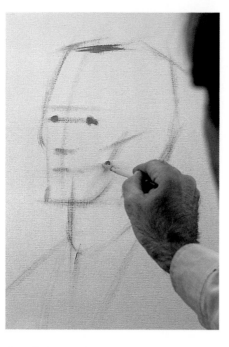
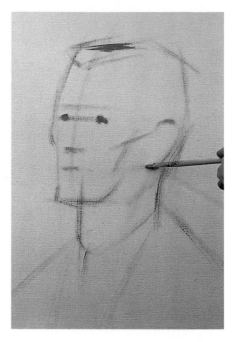

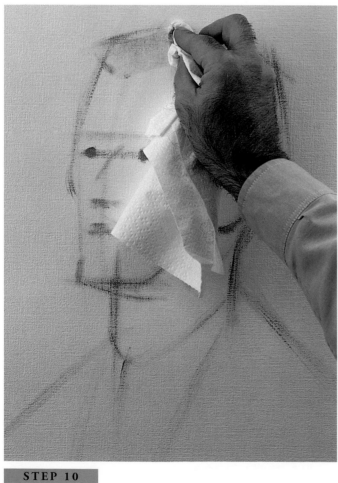

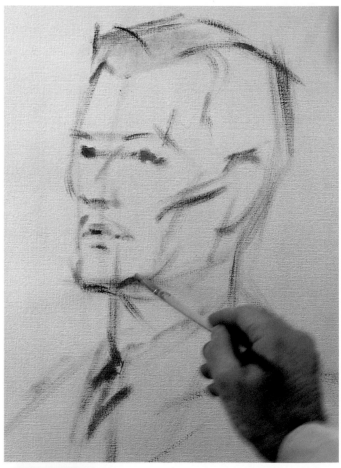

STEP 10

Here I'm making a correction, using a towel and mineral spirits to take out the mark indicating the top of the hair and replacing it a little higher.

STEP 11

Most of the significant landmarks are now indicated. Include more details in the hair, indicate the curve of the eyelids, place the outer corners of the mouth and indicate the width of the lips. Mark a few details of the collar and tie.

Indicate the "corner" of the fore-head and the edge of the shadow on the nose. Next, indicate a suggestion of the mustache and an indication of the robe and hood.

Draw the left contour of the face with a bit more care. The shape of the nose is defined now and the mouth given a touch more character. Indicate the edge of the shadow on the throat.

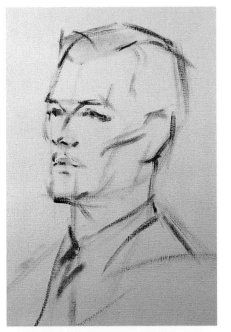

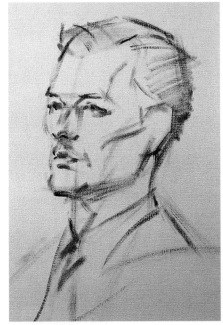

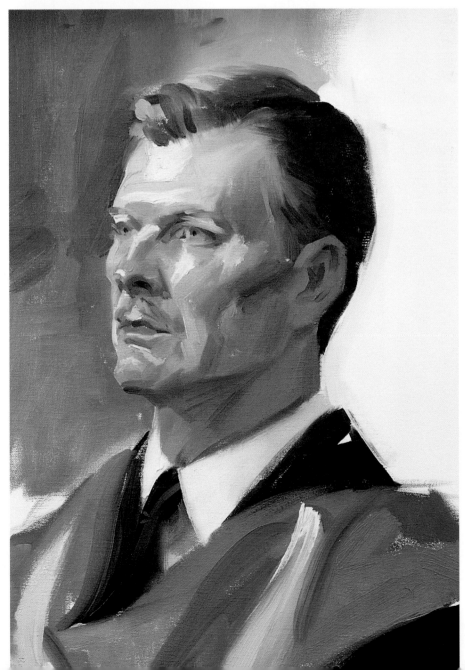

Completed Painting

Demonstration study of Dalton Dearborn

Values

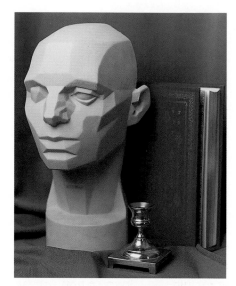

The "Local" Tone of the Object
Every object has a local tone. Here the head is light, the book is a dark halftone and the background is very dark.

Values are the degrees of tonal lightness and darkness running from white to black. Three factors establish the degree of any value: (1) its inherent local tone, which is unaffected by the surrounding tones, (2) the intensity of the light illuminating it, and (3) the angle of the plane relative to the light source.

The Effect of Light

In painting the head, you must realize you're not painting eyes, ears, noses and chins but rather the effect of light spilling over these forms.

Until you fully swallow and digest this principle, you will go on groping, fumbling and suffering intense frustration. But once you accept it as gospel, you can launch yourself on the road to artistic fulfillment.

The key lies in observing, then identifying, the degree, intensity and direction of the light striking a particular object. For instance, when painting a nose, forget that it's made of cartilage, bone, skin and other tissue, and seek to properly and accurately evaluate and place its lights, halftones and shadows. The most important factor in painting the head is not getting the eyes or the mouth right but accurately separating and rendering the range of values from light to dark.

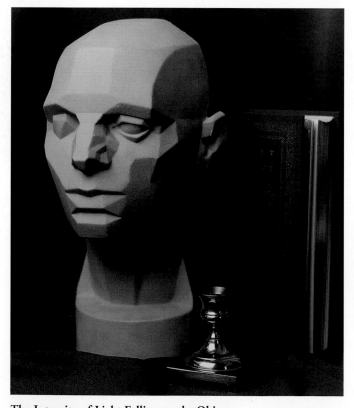

The Intensity of Light Falling on the Object
Here the intensity of the light falling on the objects has been greatly reduced. The head, which formerly was "white," is now a middle value. The book has dropped into the black range.

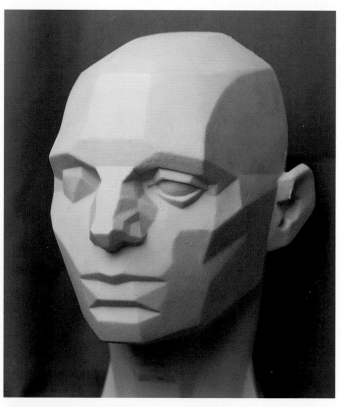

The Angle of a Plane Relative to the Light Source
All of the planes on the head are "white"—they are the same local value. The intensity of the light is the same, but the planes of the head are at differing angles to the light source, creating varying degrees of tone.

Make and Use the Nine-Tone Value Scale

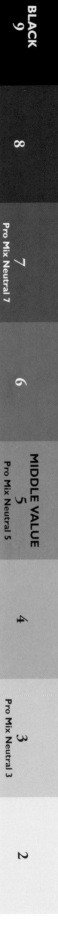

BLACK
9

8

Pro Mix Neutral 7
7

6

MIDDLE VALUE
5
Pro Mix Neutral 5

4

Pro Mix Neutral 3
3

2

WHITE
1

O ne of the most valuable aids for an artist is the value scale. The purpose of using a value scale is to learn to differentiate between values and to learn to "read" the numerical equivalent of each tone. This is an extremely rewarding exercise. A nine-tone value scale is reproduced on the right-hand edge of this page. Value 1 is pure white and value 9 is pure black. Value 5 is equidistant between the two extremes.

Using the Value Scale

Practice reading values by sighting across the edge of the scale to a tone on some other object. Begin by using an object where all of the tones are the same local value, such as the "planes of the head" model in the photograph shown at middle right. Practice until you are able to identify all the values by number.

Next, as shown below right, use the scale to identify values in a complex two-dimensional object, such as a painting. It is absolutely fascinating to discover, for example, the numerical value of the highlights in a portrait by Rembrandt, as compared with those in one by Franz Hals. Then compare the shadow tones in those same two artists. Gradually, you will become conversant with tonal values with a precision you never possessed before.

Finally, use the scale to read "real world" values, both indoors and out-of-doors. Good luck!

You can use this scale, or you can make one for yourself using your Pro Mix Color System set. Rule out nine equal squares along the edge of a piece of white cardboard. Paint pure White into square 1, Pro Mix Neutral 3 into square 3, Pro Mix Neutral 5 into square 5, Pro Mix Neutral 7 into square 7 and pure Black into square 9. Then mix and paint the intervening squares. Allow to dry.

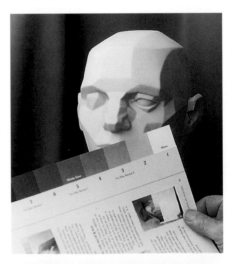

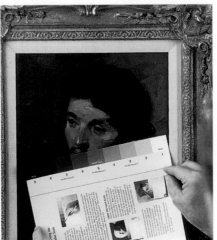

The Six Kinds of Tone

Six Do's and Don'ts for Establishing Accurate Values

1 When painting, never judge a value independently but always in relationship to at least two other values. For study purposes only, however, it's perfectly legitimate to isolate a value and seek to determine its individual place on the tonal scale.

2 Always aim for a strong, simple tonal effect rather than for a complex, fragmented one, which usually serves only to weaken a painting.

3 Be selective, simplify, don't attempt to render all the tones you see, since this is beyond human capacity.

4 Pay special attention to your halftones. They are subtle, delicate creatures, and given tender loving care and attention they will respond by lending beauty, character and sensitivity to your painting.

5 In painting highlights, paint just what you see; resist the temptation to render them lighter than they are just because they are highlights!

6 Keep a tight rein on your reflected lights lest they distort the shadow by their overaggressive, deadly attraction. Nothing can kill a shadow faster than a gorgeously overstated reflected light.

While value is, for artistic purposes, separated into nine degrees of tonality, it is also—for the same reason—divided into six different kinds. They are:

1. LIGHT. Those planes that lie generally at a right angle to the main light source are judged to fall within the light value and are painted accordingly.

2. HALFTONE. Once you tilt the plane so that it no longer faces the main light squarely but somewhat at an angle, it becomes a halftone.

3. SHADOW. When a plane turns completely away so none of the main light falls upon it, it becomes a shadow.

4. REFLECTED LIGHT. Light that bounces back into the shadow—whether as a reflection of some object illuminated by the original light source or issuing from some secondary light source—constitutes reflected light. A word of caution: Be extremely skeptical of such lights, as they tend to appear brighter than they actually are. One must exercise harsh restraint in rendering reflected lights and understate rather than overstate them lest they negate the strength and solidity of the shadow areas. Reflected lights are a terrific temptation for beginners and must be carefully monitored.

5. CAST SHADOW. When a light is intercepted by a form that then projects the effect of this interception onto another plane, a cast shadow is created. These cast shadows are usually darker than the regular shadows since they are not diluted by any reflected lights.

6. HIGHLIGHT. A highlight appears where a plane—due to its shiny or reflective character—simply reflects the original light source. This happens most often on the tip of a nose or in the eye, creating what photographers call a catch light. I must warn you, however, that this is one instance in which you must take some liberties with what you think you see. Do not ever paint this catch light smack in the center of the pupil—which gives the eye a glassy, unreal appearance—but instead place it just at the junction between the pupil and the iris at what aerial gunners would describe as the ten o'clock or two o'clock position.

One final word: Contrary to what you may have been led to believe, a highlight is not necessarily higher in value than a light!

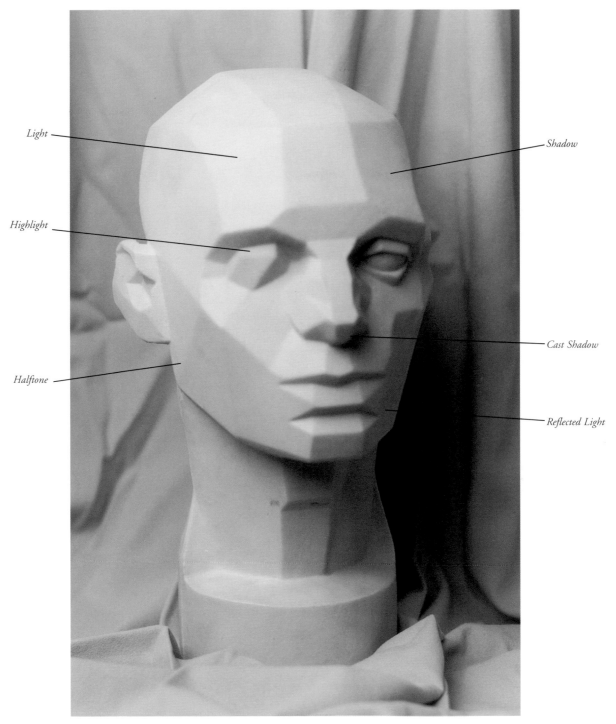

Light

Shadow

Highlight

Cast Shadow

Halftone

Reflected Light

Planes of the Head *sculpture by John Asaro*

Analyze Tone By Value and Type

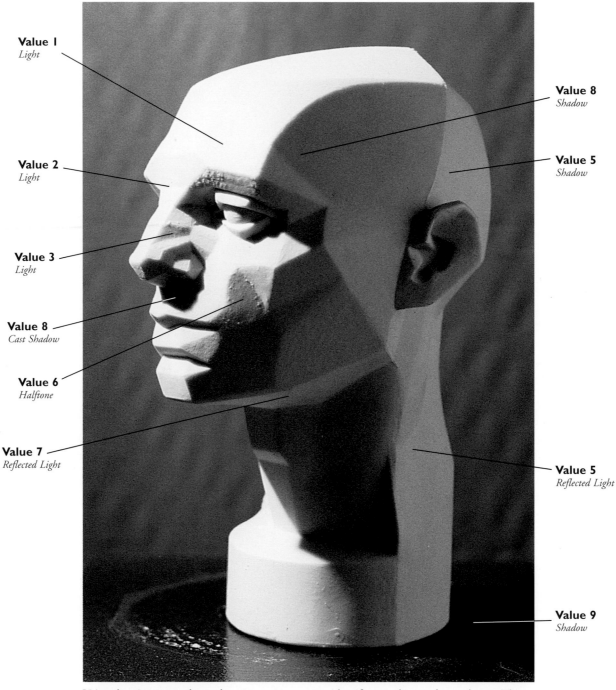

Value 1
Light

Value 2
Light

Value 3
Light

Value 8
Cast Shadow

Value 6
Halftone

Value 7
Reflected Light

Value 8
Shadow

Value 5
Shadow

Value 5
Reflected Light

Value 9
Shadow

Using the nine-tone value scale on page 31, you can identify tones by number and type. This skill is valuable for three reasons. First, you gain in perceptiveness and sensitivity to the subtle variations in tone. Second, you acquire a precise vocabulary with which to describe tone. Third, and most important, as you paint, your new tonal awareness allows you to render your visual impression with more authority and directness. Try it! It works!

Values Are Relative

We've already established that every value occupies a specific place between light and dark on the scale of nine and that for painting purposes it must be consigned by the artist to one of the six kinds of tone. However, it's vital to remember that each value also bears a positive relationship to all the other values in the painting, and this relationship is something the artist must constantly strive for.

Here are some suggestions toward this goal:

1. First establish the larger basic tonal areas, such as background and hair in a simplified fashion, and then judge the more delicate tones as they relate to these larger areas.

2. After selecting the proper color hue mixture for the upcoming brushstroke, determine value relationships by thinking of the subject before you in terms of black and white. Ignore any color considerations the subject presents. You can compare this to switching your gaze from a color photograph to a black-and-white photograph of the same subject, as shown in the sidebar on this page.

3. Mentally establish the lightest and darkest points on the subject, and see how the other areas fall into place between these two variables.

4. After fixing a mental image of the subject's tonality, always begin painting by simply stating the big areas of darks first, working gradually toward the lights. At this stage of the painting, exercise selective judgment, and work not in nine but in perhaps three values only. Later you'll have plenty of time to refine the values, but in these beginning stages aim for pure shadow, halftone and light only.

5. Experiment with such optical aids as the value scale or nine separate value cards, or use a piece of red acetate, which when looked through obliterates all color and reduces everything to degrees of light and dark. Slip the value scale under the glass of your palette, then try to match your tones to it as closely as possible.

Such tonal exercises will help fix the concept of tonal variation firmly in your mind and free you to pursue your painting unhampered by doubt and indecision as to the relationship of the values in your subject.

Visualize the Subject in Black and White

The ability to visualize and think in monochrome tonalities is one of the most important disciplines for the artist. To determine value relationships, think of the subject in black-and-white terms and ignore any color considerations it presents.

Color

To me, color is a purely visual experience. Put aside all theories, formulas and preconceived concepts, and base your color decisions strictly on observation. Nature in her infinite wisdom offers us the most beautiful and delicate color combinations, and it's up to us to see them and try to reproduce them with all the perception and sensitivity of which we are capable. When painting from life, all theories on color must fall by the wayside, and we must trust our eye to study and capture the color before us.

The key to color in painting is simply *observation!*

Color Qualities

Let's organize our understanding of color into a simple set of factors and procedures. Then we can put our use of color on a dependable and repeatable basis.

First, it is important to understand the three qualities of every color—hue, value and intensity.

Hue indicates the name of the color: red, yellow, yellow-green, etc. The fascinating quality artists refer to as temperature is really an element of hue (more on this later).

Value refers to the lightness or darkness of a color. The value of a color indicates its position on a tonal scale between black and white. This is the most important color quality for the artist.

Intensity refers to the strength, saturation or purity of a color.

Warm and Cool

Artists refer to colors as either warm or cool. The warm colors, of course, are the reds and yellows. The cool colors are the blues and greens. But each separate color within these categories can be made warmer or cooler. We speak of a cool red or a warm blue. Technically, temperature is an element of the basic quality of hue.

As you paint, you must adjust every brushload of color as to hue, value and intensity. It is a formidable task. Your mastery of color and color mixing depends on your willingness to work at it, doing exercises and committing color combinations to memory.

The Four Steps in Every Color Mixture

When observing a skilled and experienced artist painting from nature, the layman might assume that the artist's color combinations "come naturally." In fact, the painter is operating from experience and knowledge, from an understanding of what happens when certain colors combine. The four steps to every color combination are: observe, select, analyze and adjust.

1. OBSERVE. The first step is to observe nature, to observe the subject matter. Intense, sharp observation is the starting point of all good painting.

2. SELECT. Next look at your palette. Select the one color that comes closest to the color you intend to achieve through mixing.

3. ANALYZE. The pure tube colors on our palette rarely match what we see in nature. We must analyze the difference between what we observe and the color on the palette. Does the color need to be adjusted in hue (made warmer or cooler), adjusted in value (made lighter or darker), adjusted in intensity or, perhaps, all of these?

4. ADJUST. Proceed to make the necessary adjustments.
- Adjust the hue. Add what is necessary to achieve the desired hue. Temperature adjustment is part of this process.
- Adjust the value. This is the most important adjustment—to arrive at the correct lightness or darkness.
- Adjust the intensity, if necessary.

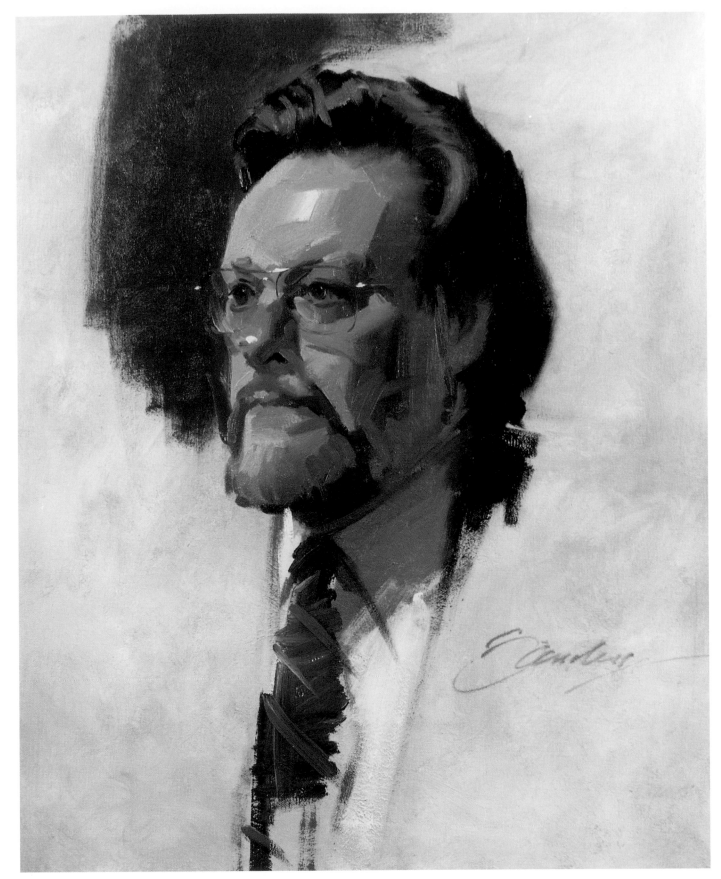

Demonstration study of James Barry

The Pro Mix Portrait Palette

Here is the palette of colors that I use in my professional portrait work and that I recommend to you. Since 1974, artists all around the world have been discovering and using this simple yet effective color mixing system, which allows you to achieve a broad spectrum of flesh colors quickly, simply and directly and to repeat the precise color combinations time after time.

The palette consists of two rows of colors. The top row has twelve standard colors, obtainable from any art materials retailer. The second row contains White, Black and ten specifically formulated colors, premixed for convenience and accuracy. By mixing one premixed color with one color from the standard palette, you can achieve an array of attractive and valuable flesh tones.

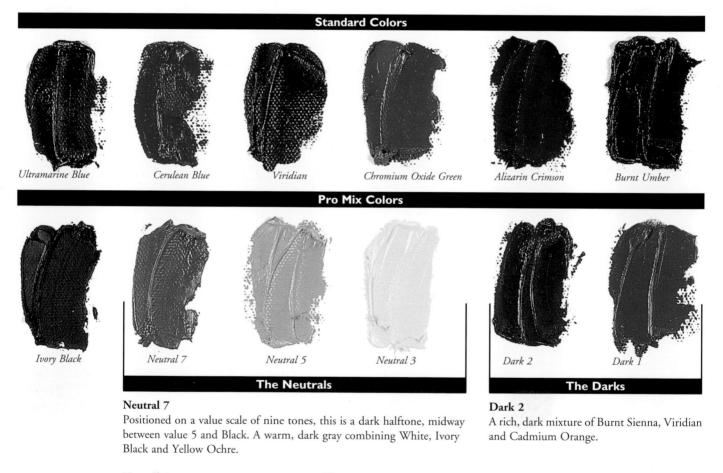

Standard Colors

| Ultramarine Blue | Cerulean Blue | Viridian | Chromium Oxide Green | Alizarin Crimson | Burnt Umber |

Pro Mix Colors

| Ivory Black | Neutral 7 | Neutral 5 | Neutral 3 | Dark 2 | Dark 1 |

The Neutrals

The Darks

Neutral 7
Positioned on a value scale of nine tones, this is a dark halftone, midway between value 5 and Black. A warm, dark gray combining White, Ivory Black and Yellow Ochre.

Neutral 5
Precisely midway between Black and White. A combination of White, Black and Yellow Ochre.

Neutral 3
The light halftone. Combines White, Black and Yellow Ochre.

Dark 2
A rich, dark mixture of Burnt Sienna, Viridian and Cadmium Orange.

Dark 1
White has been added to the basic mixture of Dark 2.

These colors are not "crutches" or a "paint-by-number" shortcut. These ten colors are, in fact, simple, traditional flesh color combinations (see descriptions) used by all portrait artists since the introduction of oil painting. For example, Light 1 is produced by combining White, Yellow Ochre and Cadmium Red Light. The resulting hue has been used by painters for the five hundred years of oil painting.

The two big advantages of the Pro Mix system are time savings and accuracy. As you make the color combinations described on the following three charts, you will note that in each case you are simply modifying one of the Pro Mix colors by adding a touch from one of the standard colors or another Pro Mix color. These modifications are based entirely on your observation of the portrait subject.

Why Are the Pro Mix Colors Numbered From Right to Left?

The majority of painters are right-handed. A right-handed painter works with his (or her) palette on the left and the light falling on the work from the left side. This arrangement prevents shadows from the artist's hand and brush from falling onto the point of concentration.

White, the artist's most-used pigment, is placed closest to the canvas, on the extreme right-hand side of the palette. The Pro Mix colors are arranged from light to dark, working away from white. Hence, the arrangement shown here and the Pro Mix charts that follow.

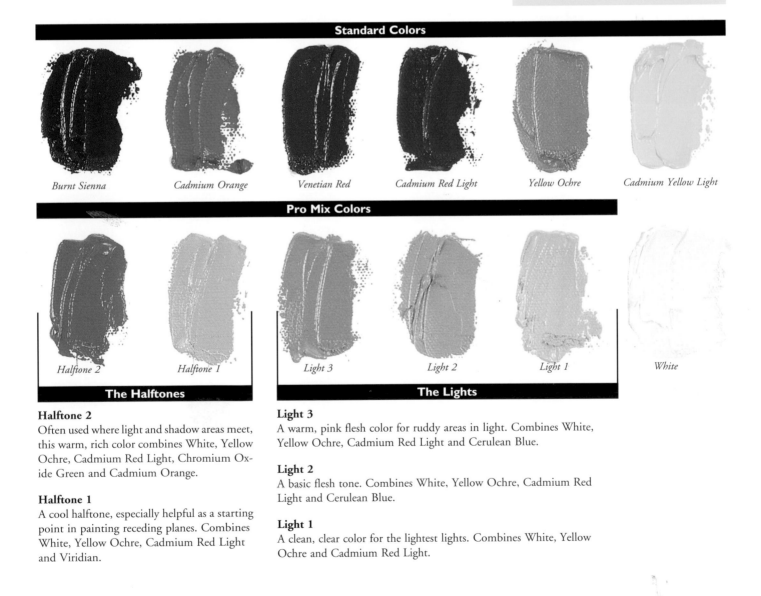

Standard Colors

Burnt Sienna *Cadmium Orange* *Venetian Red* *Cadmium Red Light* *Yellow Ochre* *Cadmium Yellow Light*

Pro Mix Colors

Halftone 2 *Halftone 1* *Light 3* *Light 2* *Light 1* *White*

The Halftones **The Lights**

Halftone 2
Often used where light and shadow areas meet, this warm, rich color combines White, Yellow Ochre, Cadmium Red Light, Chromium Oxide Green and Cadmium Orange.

Halftone 1
A cool halftone, especially helpful as a starting point in painting receding planes. Combines White, Yellow Ochre, Cadmium Red Light and Viridian.

Light 3
A warm, pink flesh color for ruddy areas in light. Combines White, Yellow Ochre, Cadmium Red Light and Cerulean Blue.

Light 2
A basic flesh tone. Combines White, Yellow Ochre, Cadmium Red Light and Cerulean Blue.

Light 1
A clean, clear color for the lightest lights. Combines White, Yellow Ochre and Cadmium Red Light.

Learn to Use the Pro Mix Portrait Palette

We have learned that three basic adjustments can be made to any color: adjusting the hue (making the color warmer or cooler), adjusting the value (making the color lighter or darker) and adjusting the intensity (making the color more or less intense).

The following charts show how the seven basic flesh colors (the Pro Mix colors) can be modified through these adjustments by the addition, in most cases, of just one color. Note that there are six possible adjustments to the original color: warmer, cooler, lighter, darker, more intense and less intense. These six adjustment possibilities are shown as horizontal bands across the chart. Some of the bands recommend as many as four possible additives (resulting in four slight variations of that adjustment), while others recommend only two or one.

Painting this chart is an essential exercise for the student of color. Begin by painting pure color, straight from the tube, into the seven squares across the top of the three-page chart. Then work down each column, mixing just a touch of the recommended additive into a brushload of the base color (at the top of the column). A foldout copy of the Pro Mix chart (with the color areas left blank so you can mix them and paint them in) is included with each set of Pro Mix Color System oil colors. This chart, printed on coated paper ideal for painting, measures 11"×32" (28cm×81cm).

Let's Take Light 1 as an Example

First, paint pure Light 1 into the square at the top of the column. Then note that in the first row of adjustments there are three possible ways in which Light 1 can be made warmer. With your brush still loaded with Light 1, dip into a touch of Alizarin Crimson, mixing thoroughly. The resulting mixture is *still* Light 1, but now it's much warmer.

Clean your brush and reload with Light 1. Now dip into a touch of Cadmium Red Light. The resulting mixture is again Light 1, but now much, much warmer. And so on.

Continue this procedure down all the columns, until all seventy-eight colors are complete. You now have a chart of seventy-eight beautiful flesh tones, almost all created by the combination of only two colors. Only in the case of making a Pro Mix color more intense will you need to add more than one color.

Gradually, you'll commit these color combinations to memory.

THE PRO MIX COLOR SYSTEM, LIGHTS

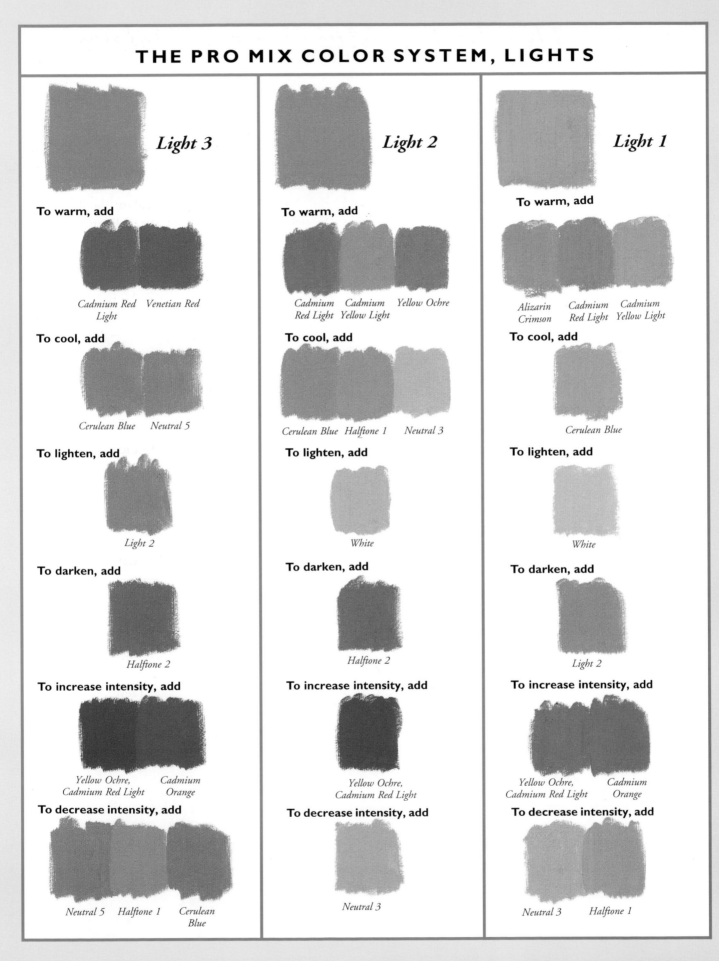

Light 3

To warm, add

Cadmium Red Light Venetian Red

To cool, add

Cerulean Blue Neutral 5

To lighten, add

Light 2

To darken, add

Halftone 2

To increase intensity, add

Yellow Ochre, Cadmium Red Light Cadmium Orange

To decrease intensity, add

Neutral 5 Halftone 1 Cerulean Blue

Light 2

To warm, add

Cadmium Red Light Cadmium Yellow Light Yellow Ochre

To cool, add

Cerulean Blue Halftone 1 Neutral 3

To lighten, add

White

To darken, add

Halftone 2

To increase intensity, add

Yellow Ochre, Cadmium Red Light

To decrease intensity, add

Neutral 3

Light 1

To warm, add

Alizarin Crimson Cadmium Red Light Cadmium Yellow Light

To cool, add

Cerulean Blue

To lighten, add

White

To darken, add

Light 2

To increase intensity, add

Yellow Ochre, Cadmium Red Light Cadmium Orange

To decrease intensity, add

Neutral 3 Halftone 1

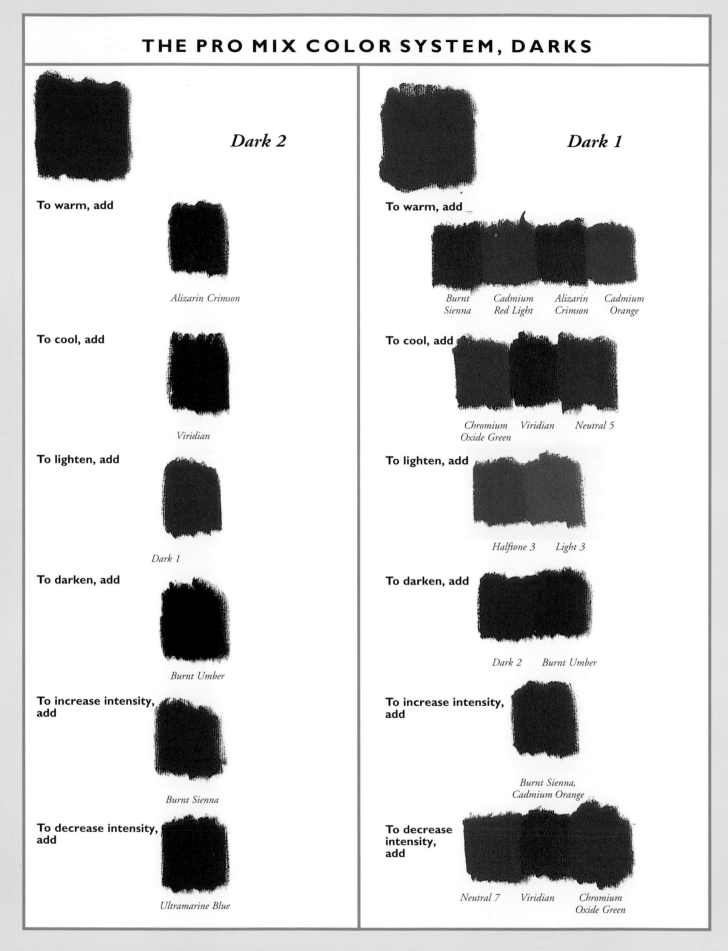

Dark 2

To warm, add

Alizarin Crimson

To cool, add

Viridian

To lighten, add

Dark 1

To darken, add

Burnt Umber

To increase intensity, add

Burnt Sienna

To decrease intensity, add

Ultramarine Blue

Dark 1

To warm, add

Burnt Sienna *Cadmium Red Light* *Alizarin Crimson* *Cadmium Orange*

To cool, add

Chromium Oxide Green *Viridian* *Neutral 5*

To lighten, add

Halftone 3 *Light 3*

To darken, add

Dark 2 *Burnt Umber*

To increase intensity, add

Burnt Sienna, Cadmium Orange

To decrease intensity, add

Neutral 7 *Viridian* *Chromium Oxide Green*

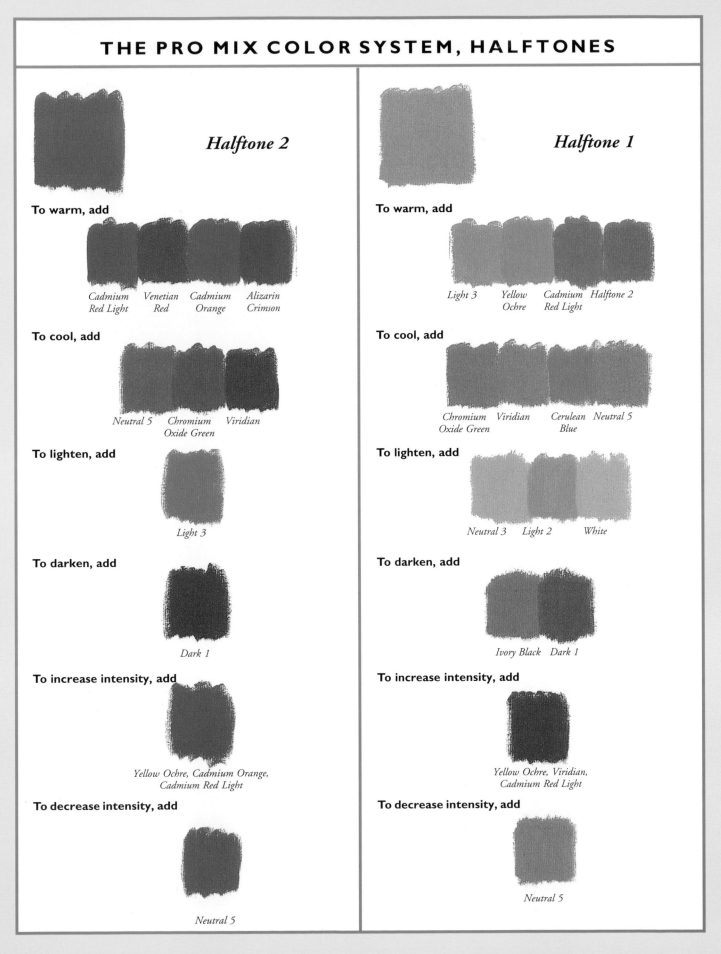

Halftone 2

To warm, add

Cadmium Red Light Venetian Red Cadmium Orange Alizarin Crimson

To cool, add

Neutral 5 Chromium Oxide Green Viridian

To lighten, add

Light 3

To darken, add

Dark 1

To increase intensity, add

Yellow Ochre, Cadmium Orange, Cadmium Red Light

To decrease intensity, add

Neutral 5

Halftone 1

To warm, add

Light 3 Yellow Ochre Cadmium Red Light Halftone 2

To cool, add

Chromium Oxide Green Viridian Cerulean Blue Neutral 5

To lighten, add

Neutral 3 Light 2 White

To darken, add

Ivory Black Dark 1

To increase intensity, add

Yellow Ochre, Viridian, Cadmium Red Light

To decrease intensity, add

Neutral 5

Now Let's Put the System to Work on Portraits . . .

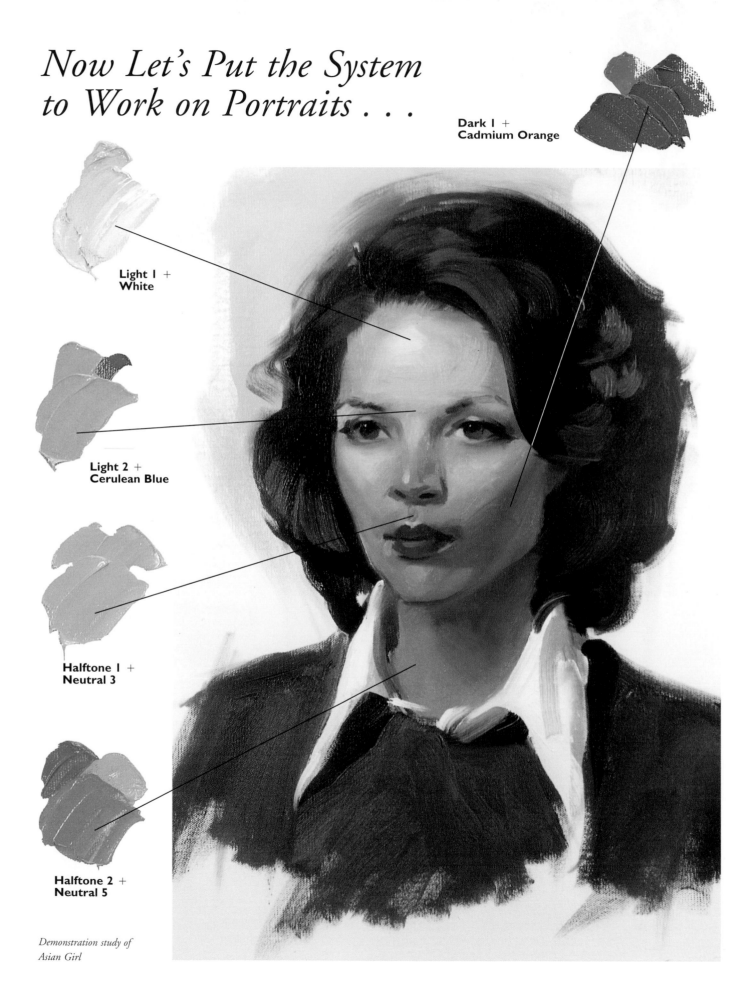

Dark I + Cadmium Orange

Light I + White

Light 2 + Cerulean Blue

Halftone I + Neutral 3

Halftone 2 + Neutral 5

Demonstration study of Asian Girl

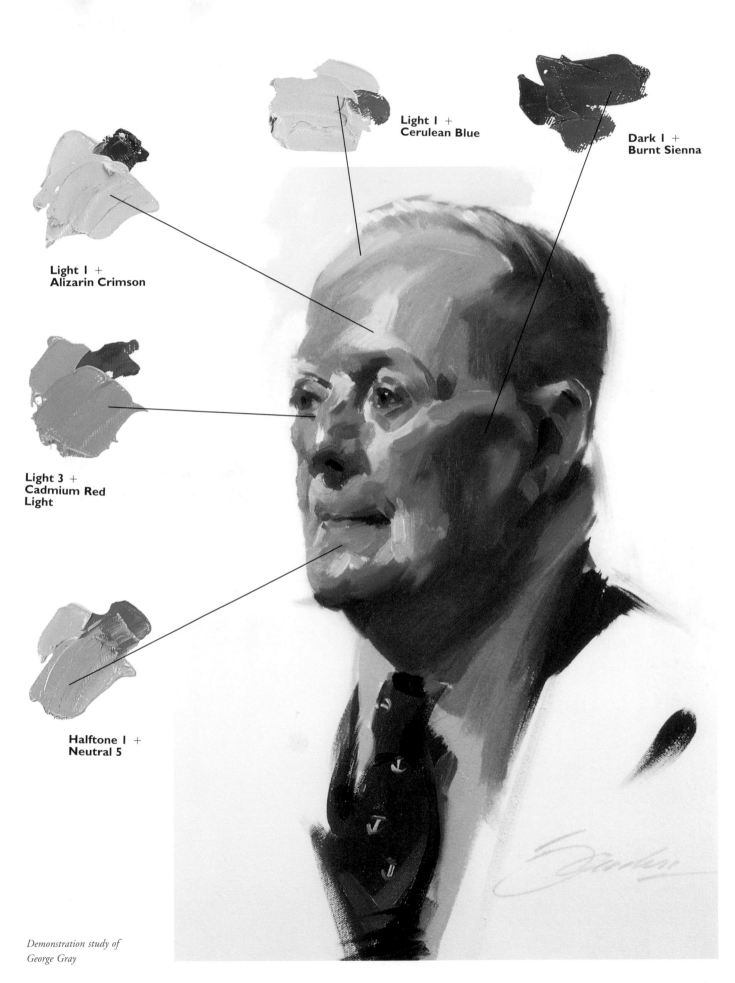

**Light 1 +
Cerulean Blue**

**Dark 1 +
Burnt Sienna**

**Light 1 +
Alizarin Crimson**

**Light 3 +
Cadmium Red
Light**

**Halftone 1 +
Neutral 5**

*Demonstration study of
George Gray*

. . . And in a Figure Painting

Dark I + Neutral 7 + Cadmium Orange

Dark 2 + Burnt Umber

Light 2 + Neutral 5

Halftone 2 + Neutral 5 + Cadmium Orange

Halftone 2 + Chromium Oxide Green

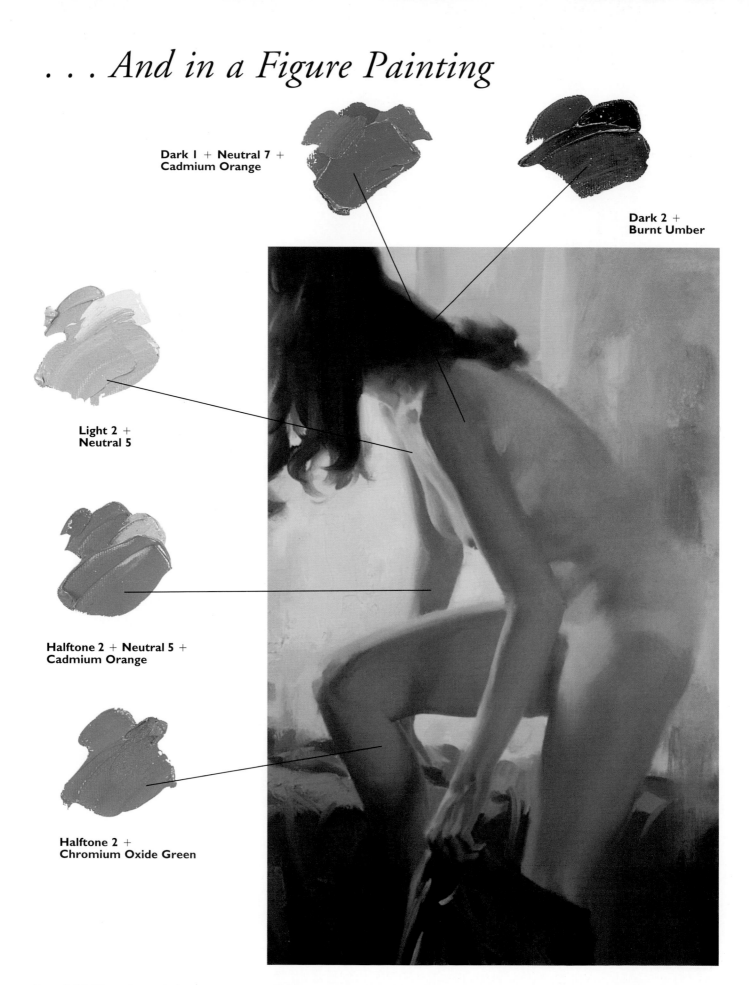

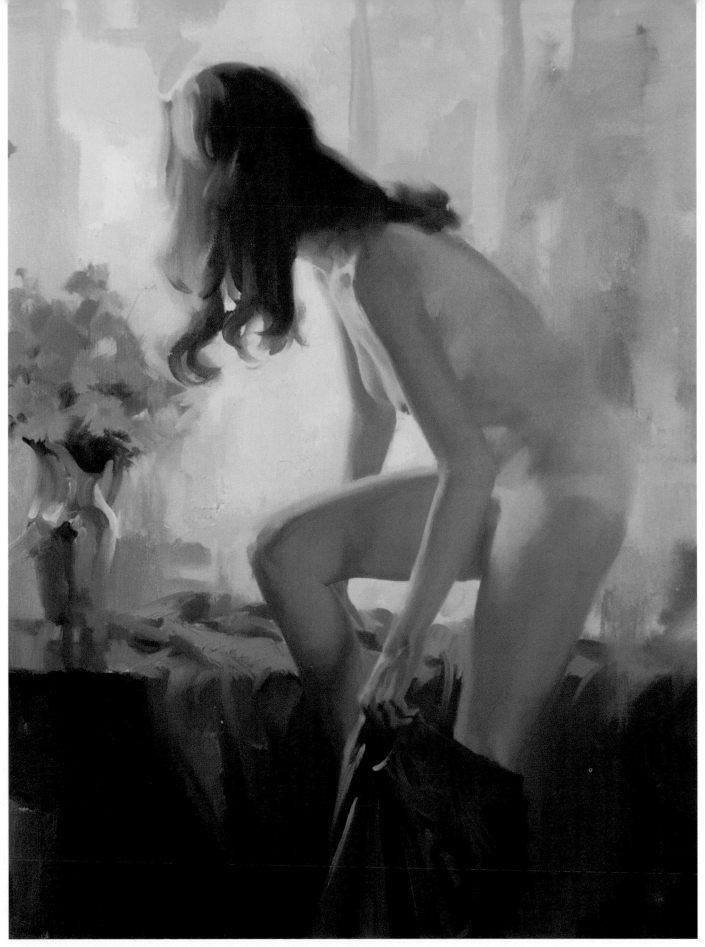

THE GREEN GOWN
Oil on canvas, 27" × 36" (69cm × 92cm)
Collection of the artist

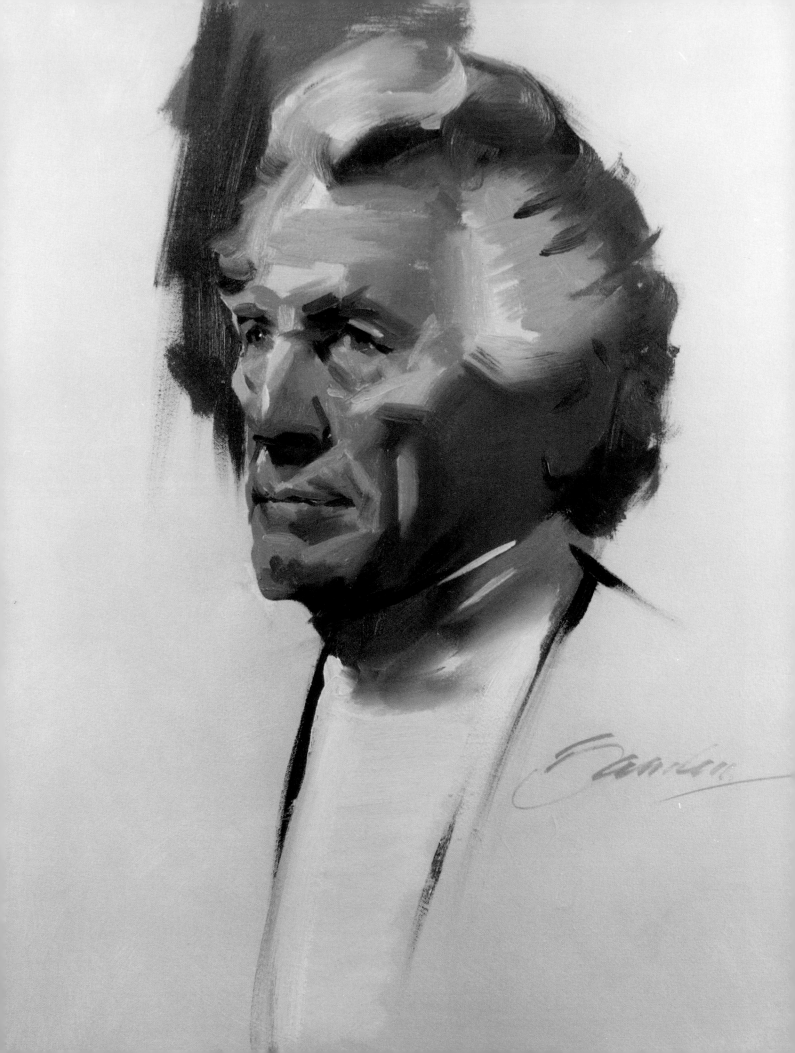

PREMIER COUP TECHNIQUE

Demonstration study of Joe Sirola

Premier Coup

The method of painting I practice and advocate is called *alla prima*, from the Italian, or (as I prefer to call it) *premier coup*, from the French. This is loosely translated to mean a direct or spontaneous attack.

Basically, this means that I attempt to execute a finished painting from the very first stroke, without such traditional intermediate steps as toning, underpainting, glazing or scumbling. And I try to complete the entire painting in one sitting, if possible. The motto of this method might be "Get it done; get it done right; get it done right from the beginning."

You must marshal all your concentration, alertness and energy so that every stroke of the brush becomes part of the finished statement, and your painting becomes unnecessary to correct or modify in subsequent sessions. Leave nothing to chance, but concentrate all your effort upon getting it right the first time. In a way, this method represents a kind of Evel Knievel leap over a chasm—the performer gets only one chance.

Naturally, this is the ideal. You'd have to be a Leonardo to achieve it each time you step up to your easel. Nevertheless, it's the ideal you should shoot for and keep uppermost in your mind when you come face-to-face with the blank canvas.

Incidentally, this principle of striving for the finished effect from the very first stroke applies to paintings of any size, subject or degree of complexity. Even if I'm confronted by an involved composition containing several figures, I work one section at a time until it's done.

Now let's consider the nine principles governing this method of painting.

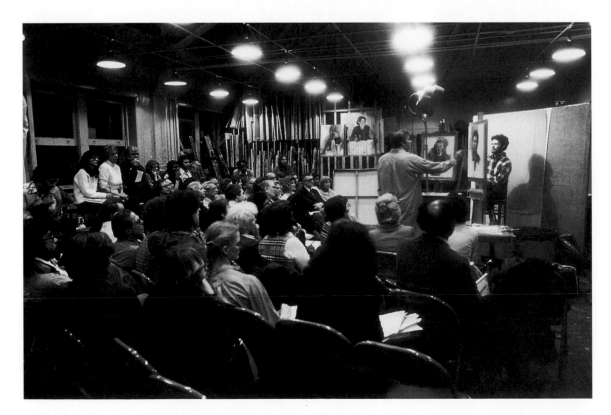

This picture shows a typical demonstration night at the Art Students League in New York sometime in 1980. I am painting the portrait study that appears on the facing page. The procedure I am demonstrating (and that is the subject of this book)—the direct study from life in a single sitting under a restricted time format—is one of the best training disciplines for the artist.

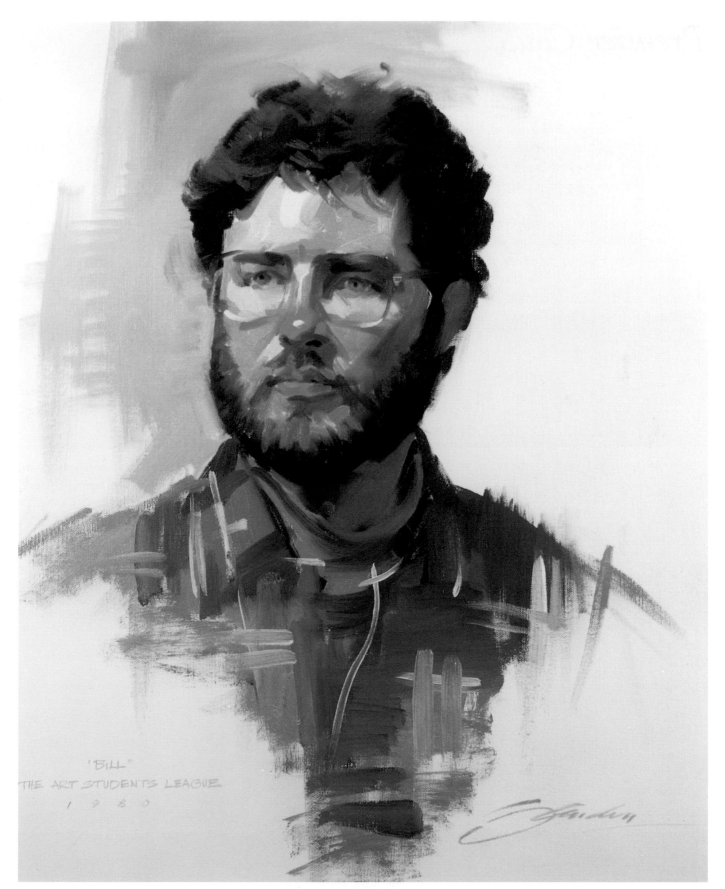

Demonstration study of William Pease

Principle 1: Start With a White, Untoned Canvas

I paint on a white, untoned canvas, since this seems to reflect the colors in the truest and clearest fashion. Another reason I rarely tone the canvas is because I use a white palette. White canvas serves as an accurate match for the palette, so I can take the paint from palette to canvas knowing beforehand how the paint will appear on the surface. I also enjoy the feel of the bare canvas texture against my brush—this seems most sympathetic to my efforts.

For the *premier coup* method, which calls for a single layer of paint laid in as swiftly as possible, toning the canvas in advance is a contradiction in terms and is useless. It is contradictory because toning the canvas implies judgment prior to observation. It is useless because the subsequent paint should be a correct and final statement, without support from preliminary toning.

The Nine Premier Coup *Principles*

1. Start with a white, untoned canvas.
2. Establish your goal.
3. Make every stroke count.
4. Be deliberate and decisive.
5. Focus on the larger masses.
6. Maintain the drawing.
7. Work with speed.
8. Treat your edges softly.
9. Overcome the fear of failure.

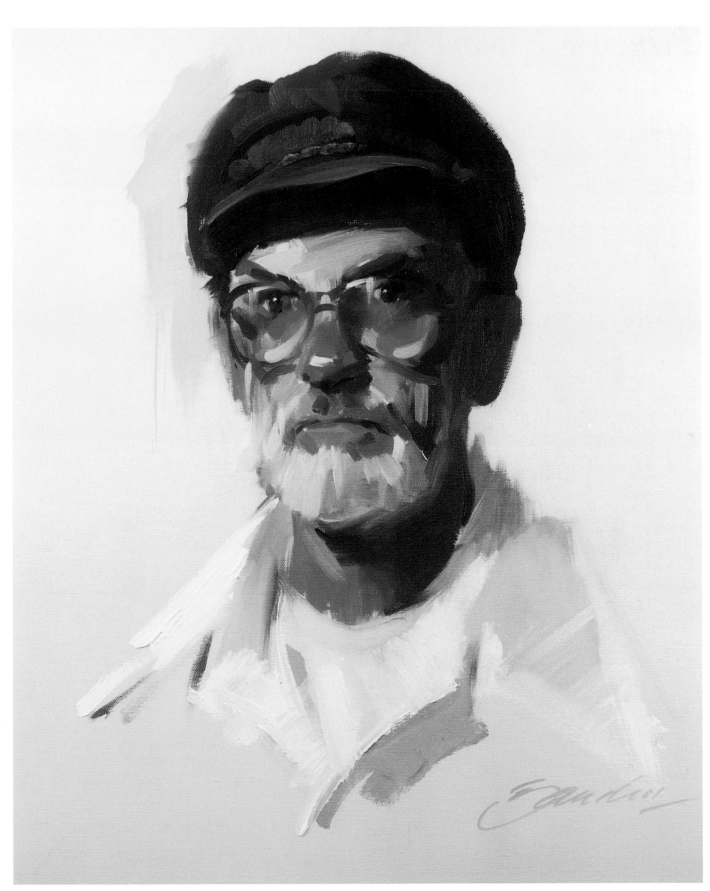

Demonstration study of a bearded man

Principle 2: Establish Your Goal

There may be fifty or more goals that artists seek in the execution of their paintings: Achieving a beautiful color scheme, defining the esthetic qualities of a scene and portraying a mood are just a few.

Make it your goal to capture the character of your subject in the simplest, most direct, most immediate fashion possible! One might call this a kind of "impressionism," but not in the sense the term is customarily used in painting. What I advocate is simply that you paint what you see. In short, (1) be as accurate and true as you can in evaluating the appearance of the subject before you and (2) reproduce this image as simply and faithfully as you can, while exercising the greatest degree of economy to achieve your statement.

To paint what you see, you must accurately capture the subject's inner and outer traits, contours and dimensions, which together constitute the subject's total character. At the same time, you must inject your personality into the effort, so the painting becomes your personal statement—your reaction to, appreciation of and pictorial reproduction of the divine creation that is a human life.

If three words are to exemplify your goal in painting, let them be simplicity, directness and accuracy.

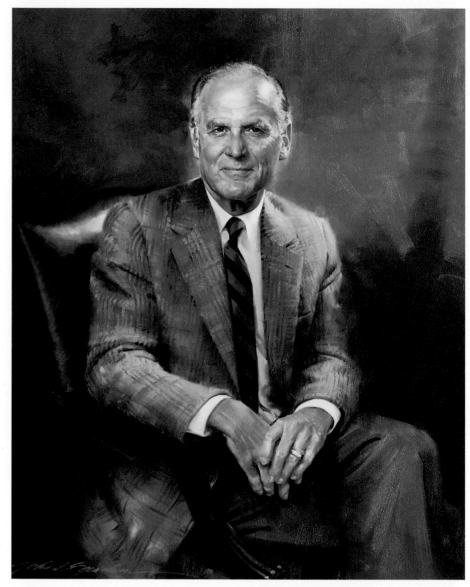

HARRY BARBEE, JR.
Oil on canvas, 34" × 42" (86cm × 107cm)
Collection, Woodberry Forest School
Woodberry Forest, Virginia

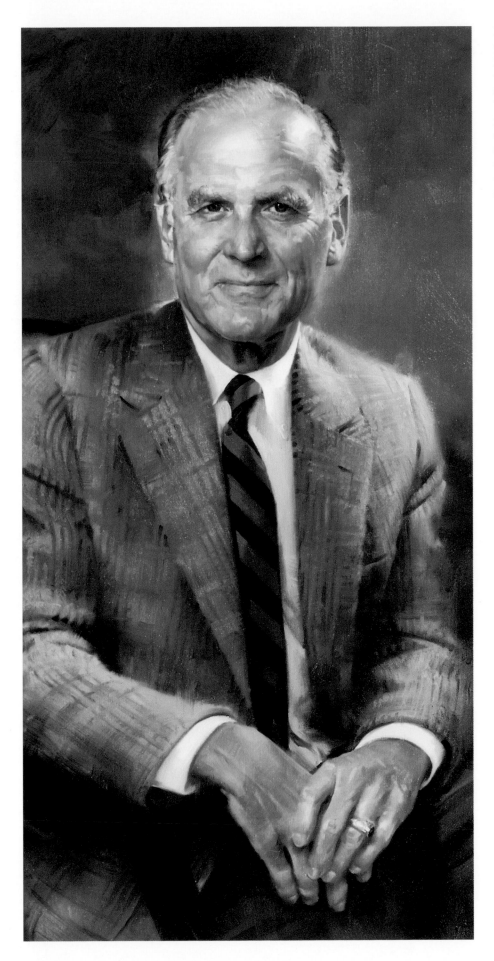

Make it your goal to capture the character of your subject in the simplest, most direct, most immediate fashion possible. One might call this a kind of "impressionism," but not in the sense that is customarily used in painting. What I advocate is simply that you paint what you see. In short, (1) be as accurate and true as you can in evaluating the appearance of the subject before you, and (2) reproduce this image as simply and faithfully as you can, while exercising the greatest degree of economy to achieve your statement.

Principle 3: Make Every Stroke Count

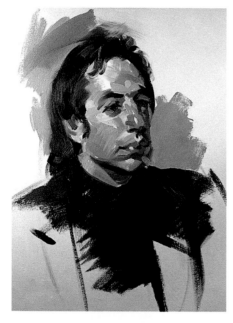

Demonstration study of Steven Winfield

This method of painting may be compared to a surgical procedure in which the patient's life hangs on the surgeon's ability to make every move vital and meaningful to the success of the operation. One stroke of the brush must do what thirty strokes may lead to in less disciplined technique. Therefore, in order to make every stroke count:

1. Use the biggest brush for the job at hand. How do you tell if it's the proper brush? If it feels a bit too large, then it's exactly right.

2. Make sure every brushful of paint is correct in every way—hue, value, intensity and position—before you touch the canvas. These four factors are riding on every stroke you apply, so think and preplan and avoid purposeless sloshing and slapping of paint.

 How do you ensure the hue, value and intensity of a brushful of paint are correct? Stare intently from subject to palette and back again until you've mixed the exact combination on the palette. When loading the brush, remember that the color of a mound of paint can never be correct if its value isn't correct.

 How do you ensure its proper position on the canvas? Follow the example of the great John Singer Sargent. In the words of one observer, Sargent's brush "hung in the air" as the master took careful and deliberate aim before allowing it to settle in its appropriate spot on the canvas. It's almost like aiming a rifle at a target: A fraction of an inch off is enough to spoil the effect.

3. Paint with the assumption that what you're painting on the canvas is there to stay and not to be changed later. A painting is like a mosaic, with each brushstroke representing a separate, important tile; seen together, the tiles constitute the total picture. Mosaic tiles can't be covered up, but must be correct from the start—and so must every stroke of your brush. Therefore, the color and placement of each stroke must be the product of a well-thought-out decision. If the hue, value, intensity and position aren't correct, the paint doesn't belong on your canvas in the first place.

4. Don't be afraid to rub out and begin anew. Many beginners fall into an obstinate determination to follow a course even if it's the wrong one. An important axiom to remember is: One false statement leads to another. If the original strokes are almost right, but not quite right, you'll end up with a painting that's almost right—and therefore totally wrong. Every stroke is conditioned by those lying beneath it and next to it. So, every stroke must be the right stroke. If a stroke isn't right, rub it out and start over!

Making every stroke count by following these four rules won't necessarily ensure the success of your painting, but letting a few incorrect strokes remain on the canvas will guarantee its failure.

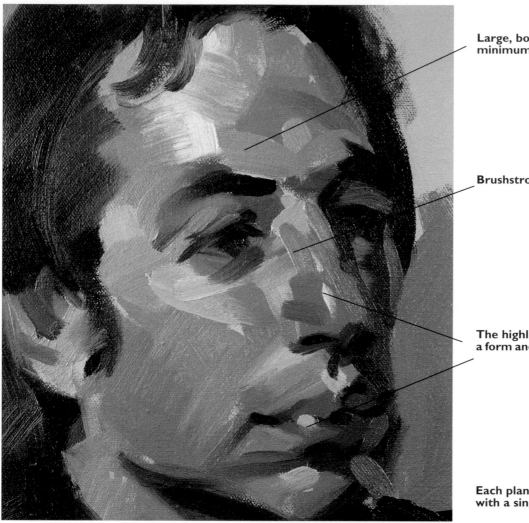

Large, bold brush strokes with a minimum of blending.

Brushstrokes go *with* the form.

The highlights are the final stroke on a form and are left unaltered and crisp.

It's sometimes amazing how few brushstrokes are required for a convincing head. This is not a completed portrait. A client commissioning a portrait is likely to expect considerably more "finish" than this. But a painting like this can really "speak."

Each plane of the mouth is expressed with a single brushstroke, if possible.

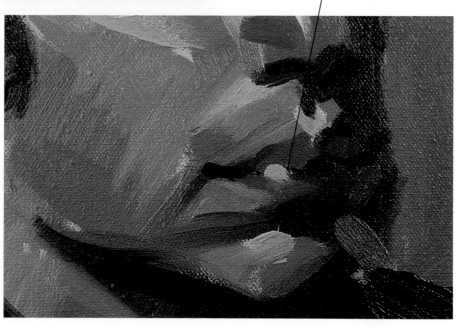

Principle 4: Be Deliberate and Decisive

While the *premier coup* method goes hand in hand with a speedy execution, it's far more important to be deliberate and accurate than merely fast. Therefore:

1. Think before you mix and place a brushstroke. Three precise strokes during a painting session are more productive than a hundred sloppy, unplanned, "spontaneous" ones. Think before you act.

2. Observe sharply; be deliberate and decisive. Learn to observe and then evaluate the effects of these observations. Reach deep within and ask yourself: Why can't the first stroke I make be the final statement I really wish to make about some particular part of the subject?

Personally, I don't want to see a single thing on my canvas that doesn't belong there, and I urge you not to put down a single stroke that hasn't been carefully observed, planned and considered. One of the greatest appeals of the *premier coup* method is that it forces you to draw on all your mental, emotional and physical resources and to lay your artistic life on the line with every stroke, by acting with deliberation, decisiveness, economy and dispatch.

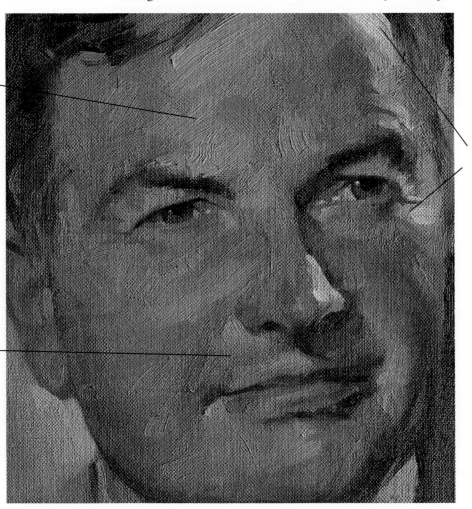

Avoid conscious blending as much as possible. Allow the strokes to remain separate. Think of the painting as a "mosaic of colors."

The highlights are richly opaque and are the last strokes "on top."

The interplay of warm and cool colors on the face adds visual as well as psychological interest.

DAVID ROCKEFELLER
Oil on canvas, 16" × 20" (41cm × 51cm)
Private collection

Principle 5: Focus on the Larger Masses

Until now I've urged you to make every stroke count and to practice economy of effort. However, without losing sight of that, certain limitations must be taken into consideration.

Unless you're Frans Hals, you won't be able to paint a finished head stroke-by-stroke without some preliminary, underlying steps. Those of us who are less than absolute masters must proceed to this goal in stages. Most of us, for instance, can't paint a finished eye right on the bare canvas. We must prepare some kind of base, a guideline upon which we can then proceed to lay in the final strokes. This guideline forces us to view the head as a series of large masses over which surface details such as eyes and lips are superimposed. If we don't paint the large mass of the head first, but just attack the eye, we might fall into the trap of getting the color of an iris "just so" without considering its correct placement within the socket.

Therefore:

1. Look at your subject as a series of large masses. After you've visually reduced the subject to three or four basic elements composed of light, halftone and shadow, proceed to paint in these large masses over your preliminary drawing, using the biggest brush at hand.
2. Once you've blocked in these large masses, paint in the smaller details that lie within or upon them. It can't be overemphasized, however, that even as you paint these subsequent details you must continue to cling to the concept of the head as a series of large masses! To see these masses as you work, you can shift from sharp to blurred focus by squinting slightly.

To illustrate: When you're painting in the eyes in the later stages, you should still maintain a mental picture of the dark mass of the sockets into which you then "drop the eyes like poached eggs into a plate," as Sargent put it. Thus, while you're painting the iris, cornea and eyelids with accuracy, you're also remaining faithful to the larger mass that lies beneath and supports them.

Thinking in large masses allows you to proceed in a natural sequence from broad, sweeping strokes to smaller, more precise strokes, while maintaining a vision or memory of the underlying structure. After all, you wouldn't fit in a windowpane before you've set up the beams, plastered the wall and put up the window frame.

The rule is that if the basic large masses are correct, chances are the features and surface details will fall into proper place as well. But the principle of working from big to small and from rough to refined is carried through only as far as necessary. When you've achieved your goal, stop—even if the ear seems unfinished or the neck or hair lost in shadow. To go on is mere gimmickry and adds nothing either to the painting or to your luster as an artist.

HARRY G. HOHN
Oil on canvas, 42" × 34" (107cm × 86cm)
Collection, New York Life Insurance Company

Principle 6: Maintain the Drawing

Keep in Mind

As you progress, always remember you are modeling a form, which is the same as drawing. Be true to what you see before you, not to what you think you should see. Retain the mental image of your drawing, and when an error appears wipe it out mercilessly!

Make a preliminary drawing with your brush, even though these strokes will be completely covered in the process of laying in the larger masses. This often puzzles my students, who quite logically ask what purpose the drawing serves, since it will be obliterated so quickly.

My answer to them and to you is: You must retain the mental image of this drawing, just as you must remember the larger masses while painting the smaller details over them. Mentally refer to this image as you proceed with the painting. This demands concentration and alertness, which—you may recall—are two of the requisites of the *premier coup* method.

When you keep this drawing guideline fixed in your mind, you keep the painting fresh and in a constant state of renewal. You mentally measure any deviation from the accurate contours and proportions against both the subject in front of you and the fixed mental image. Make corrections right on the spot, even if it means wiping out an area and repainting it.

Each time you make a calculated decision where to place a stroke on the canvas, you're drawing. What's essential is that you assume a supercritical attitude toward your own efforts, and change a passage the very moment you spot an error. Never leave it for later—fix it now! This way, you'll remain alert throughout the session and not permit some beautifully brushed effect to remain just because it's "so gorgeous," even though you know that it's essentially inaccurate.

Principle 7: Work With Speed

As a student, I once attended a painting class that lasted three hours, and subsequently I trained myself to complete the painting within that time period. Later, I took private lessons with the same teacher, but this time the sessions lasted only two hours. Naturally, I adapted myself to this new schedule; in a matter of weeks, I learned to complete the painting within two hours. Soon I began to ask myself what I had done during that third, unnecessary hour!

Time is precious and you must force yourself to paint as quickly as possible, but make sure all the while not to lose one iota of quality or accuracy as you speed your efforts. "Get it right" is more important than "Get it done."

Make sure each step is correct before proceeding to the next, no matter how long this may take. Don't go from painting masses to painting features until those masses are right!

PAM, AGE 10.

Principle 8: Treat Your Edges Softly

In real life most edges look soft because our eyes are in constant motion. An edge only assumes a sharper contour if we specifically focus on it. Apply this principle to your painting.

Keep your edges soft unless (1) you want to draw the viewer's eye to a particular area for compositional reasons, or (2) you wish to make an area appear to advance. A sharp edge or edges fulfill both these goals.

Avoid an excess of hard edges in any painting, because they're the greatest enemy of the illusion of realism. However, a painting totally lacking sharp edges tends to be less attractive than one containing a few. A hard edge is a powerful means of drawing attention to an area of emphasis in your painting.

So, keep most of your edges soft, then strike in one or two hard edges in strategic places to add spice, tang and interest to your painting. Always ask yourself, "Is the edge I'm seeing really hard or am I merely assuming that it's hard?"

SUZANNE MCKINNEY
Oil on canvas, 40" × 50" (102cm × 127cm)
Collection, Mr. and Mrs. Charles McKinney
Raleigh, North Carolina

Background objects should generally be in "soft focus," "mushy." Be sure the detail is crisp and real.

Observe how great portraitists allow colors and tones to flow together wherever possible.

Where two shadow planes meet is an excellent place to merge the forms. This unifies the tonal pattern of the painting and enhances the realism.

A firm edge here emphasizes the figure, bringing it out from the background and adding to its "substance."

The point at which two light-struck planes meet and are near in value is an excellent place to "flow" the colors.

Allow your planes to flow together wherever possible, and use firm edges judiciously for compositional emphasis or to make a form advance. I was delighted when my colleague Tom Nash, the noted Atlanta-based portrait painter, referred to the practice of achieving flow between forms as "Sandenizing." Whatever you wish to call it, the technique of allowing the colors of one form to be deliberately worked into the adjoining planes is a delightful way to loosen up a painting and get a visual dynamic going. Paintings have a way of tightening up as they are worked on. This gets the painting "going" again.

Principle 9: Overcome the Fear of Failure

Timidity is the artist's worst enemy and boldness the most faithful ally. Never tiptoe about or sneak up on your painting, but attack it with all the daring, resoluteness and decisiveness at your command. Even if you're quaking with self-doubt, try to boost your confidence before commencing a painting session, using any method that works for you. Tell yourself that you must paint with assurance, with bravado, with complete disregard for the dark doubts that gnaw at the core of every human being.

Here are two methods to help this attitude along:

1. Squeeze more paint than you'll need onto your palette. Paint is relatively cheap, and there's nothing more defeating than attempting a bold approach with tiny dewdrops of color, daintily laid out upon your palette. Lots of paint helps you work richly, broadly, sweepingly and daringly.

2. Avoid judging your rate of progress against others. Some people improve rapidly, some improve slowly. Some improve in stages, remaining at one level for years at a time, then moving ahead. There's no formula for artistic progress: It proceeds at its own pace. Some people even retrogress, going two steps forward and one back. Others leap ahead. Do all you can to improve, but let your rate of progress determine itself.

Over the years, I've noted certain patterns that govern the progress of art students. Those who approach their work with total ambition, with no timidity, with confidence and with even a kind of arrogance seem to attain their goal with greater frequency. The three traits that seem to count most are a burning desire, perseverance and a healthy dissatisfaction with everything you've done before, coupled with the urge to do it better the next time.

Remember, a bold failure is better than a timid semi-success. Take risks—it's the only way to achieve the big success. And, once you do succeed boldly, you will experience a tremendous boost to your confidence. That one big success will hook you on painting for life.

A noted theologian, paraphrasing Descartes, said: "If you think, you will become." The power of positive thinking plays an enormous part in the development of an artist.

Demonstration study of Izmi Vicelli

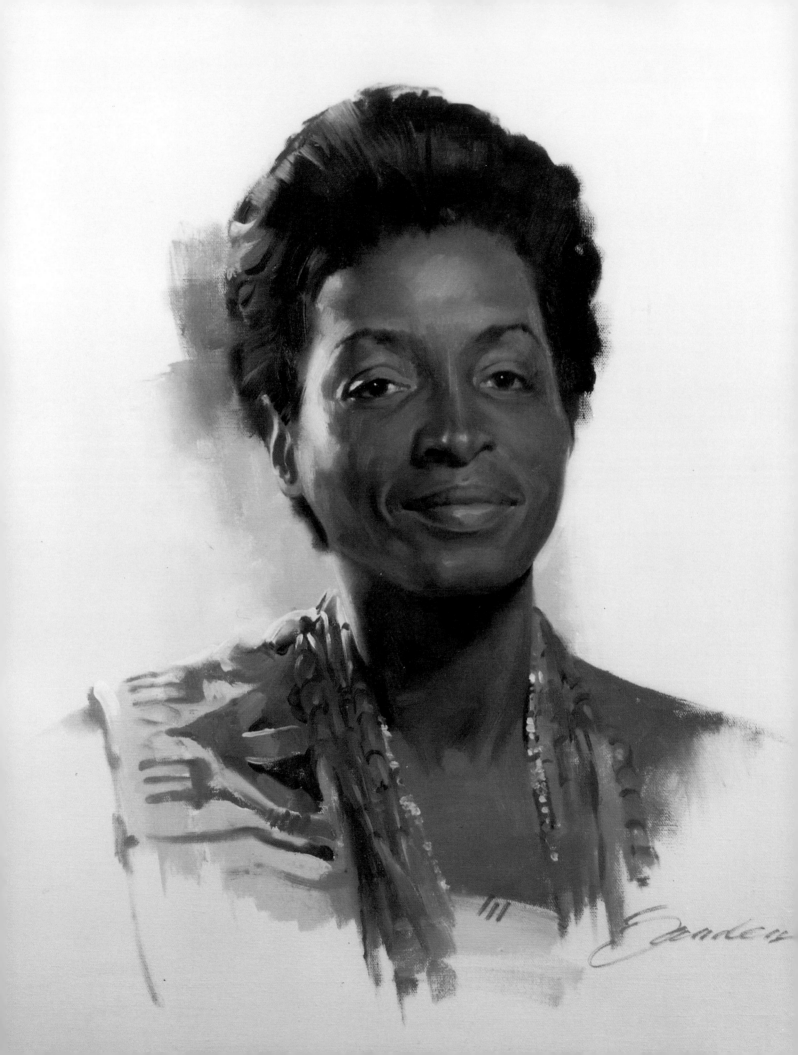

PART FOUR

STEP-BY-STEP DEMONSTRATIONS

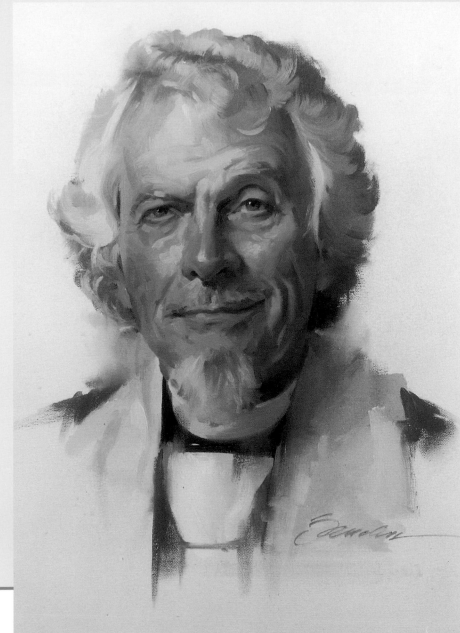

PAINT THE HEAD IN 29 STEPS

CATEGORY	STEP	STEP DESCRIPTION
Layout	1	Establish size and placement
	2	Block-in basic shapes
	3	Subdivide face mass/hair mass
	4	Establish central facial axis
	5	Map landmarks
	6	Divide light and shade
	7	Define significant landmarks
Darks	8	State shadows
Halftones	9	Transition halftones
	10	Halftones in lower third of face
	11	Halftones in central third
	12	Halftones in upper third
	13	Halftones in hair
Lights	14	Lights in central third
	15	Lights in lower third
	16	Lights in upper third
	17	Lights in hair
Restate	18	Restate darks
	19	Introduce reflected light
	20	Restate halftones
	21	Restate lights
Particularize	22	Model eye area
	23	Paint eye details
	24	Model nose area
	25	Paint nose details
	26	Model mouth area
	27	Paint mouth details
	28	Paint hair details
	29	Finishing touches

The Bishop

I want to demonstrate a logical, direct method for painting a convincing portrait head in a single sitting, using twenty-nine specific steps. I have demonstrated this procedure before audiences at the Art Students League and the Portrait Institute in New York and across the country for nearly three decades. I hope you will study the procedure carefully and conscientiously attempt to follow it. I believe you will find that this logical procedure will give you the discipline and focus that the difficult art of portraiture demands. There is plenty of room for intuition and creativity. Following a definite procedure builds assurance and competence. Good luck!

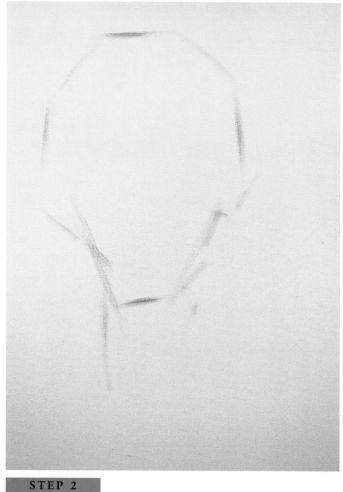

STEP 1

Establish Size and Placement

These four strokes are extremely important to establish the size and placement of the head. Here the marks are at the top of the hair and the bottom of the goatee, indicating top to bottom, and the outside edges of the hair side to side. I use a no. 4 bristle and Neutral 5. The head is life-size, established by a careful measurement with calipers. The placement (in this case on a 24″ × 20″ [61cm × 51cm] canvas) is at an appropriate place in the upper portion of the canvas with the head more or less centered, side to side, in the picture area.

STEP 2

Block In Basic Shapes

Now establish the basic outer shape of the head, using rather straight lines. Don't record details, but strive to establish the general shape by means of angles.

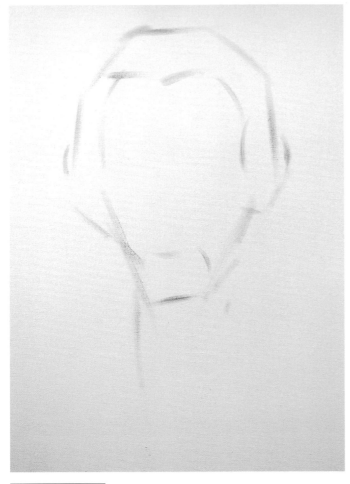

Subdivide Face Mass/Hair Mass

Now separate the hair mass from the face, showing how the hair falls across the forehead. The goatee is facial hair and thus is part of this exercise. Note again that these are all rather straight strokes. No details are indicated.

Establish Central Facial Axis

In this straight-on pose, the central axis of the face curves ever so slightly due to the oval shape of the head. Think of the seam on a football.

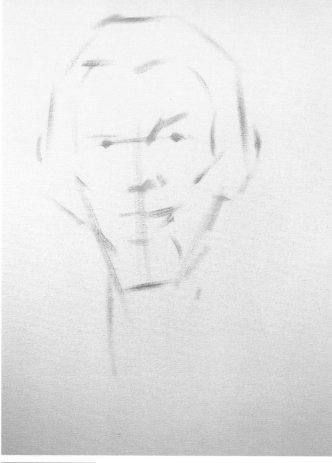

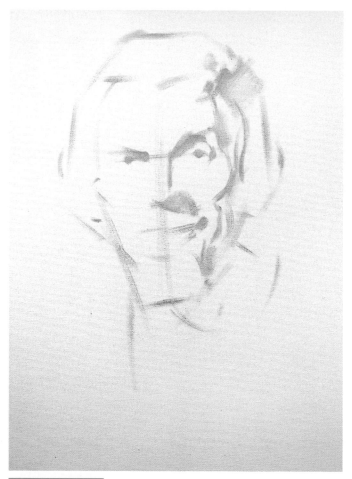

STEP 5

Map Landmarks

Next "map" the landmarks. Don't paint eyes, nose, mouth, etc., but indicate their positions on the terrain of the face. A stroke indicates the left eyebrow, two strokes the right eyebrow. Also mark the axis on which the eyes will fall, the base of the nose and the edge of the shadow on the lower lip.

STEP 6

Divide Light and Shade

The corner where the front plane of the face meets the side plane is where the light divides from the shadow. On the bishop's face, the muscle beside the mouth on the right side (as we look at it) catches the light while the shadow falls below. In the hair, the division is somewhat difficult to see because of the soft quality of the curls and because each curl has its own light and shade pattern. The cast shadow on the shoulder is very important because it helps give the head its three-dimensional quality. Some other important shadows to clarify are the cast shadow of the nose, the cast shadows at the corners of the mouth and the cast shadows in the eye sockets. I use only a mild shading to reinforce the edge where the light and shade meet.

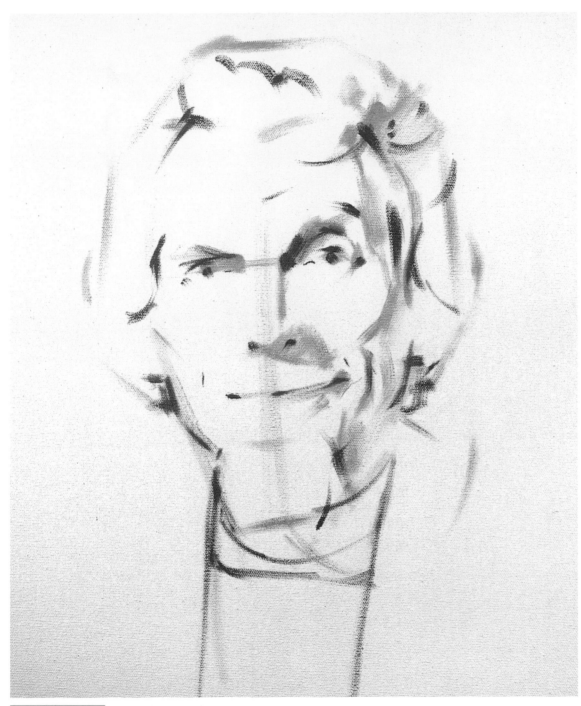

Define Significant Landmarks

Take your no. 2 bristle with Neutral 7 on it, and begin to carefully pinpoint the major landmarks, such as the pupils of the eyes, the lower edge of the upper lid, and so on. Notice the dramatic natural difference in the size of the two upper eyelids. I noted the location of the nostrils and the corners of the mouth, trying even at this early stage to suggest elements of a slight smile. Also address the part in the hair, the hair curling over the forehead and the position of the earlobes in relation to the mouth and to each other. Remember, at this point, we're establishing landmarks, not painting features. Take plenty of time at this stage and be prepared to use your mineral spirits as an eraser when needed.

State Shadows

Use a mixture of Dark 1 with Chromium Oxide Green added for the first shadow. Additional shadows are a slightly darker mixture. Don't worry about covering up the drawing of landmarks. Notice that the mustache contributes to the shadow on the mouth. Use a warm gray mixture of Neutral 7, Ivory Black and Dark 1 for the hair. The shadows occur wherever the main light does not strike. Block in your shadow tones and squint your eyes to simplify the masses. The tonal changes here are so dramatic that I was forced to use more mixtures than might otherwise be necessary at this point. The shadow on the white collar is a cool mixture of Neutral 4 (Neutral 3 plus Neutral 5) and Chromium Oxide Green. The tippet (the bishop's liturgical scarf) is a golden cream color, so add warmth to your mixture. Remember that it's one shadow falling over several objects, each with a different local color.

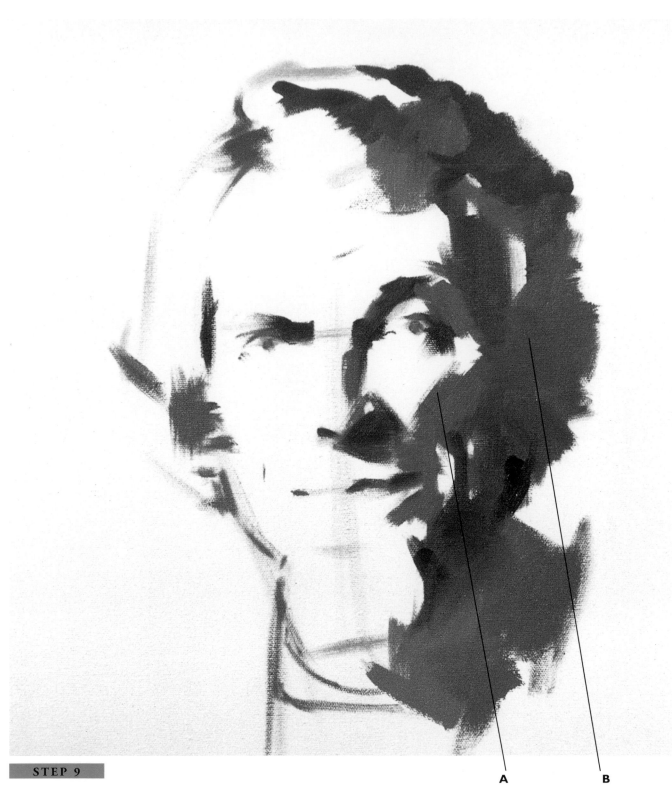

A

B

Transition Halftones

The main halftone at the edge of the darks is a mixture of Halftone 2 plus Cadmium Red Light (A). Here the halftone is very intense and bridges the tonal gap between light and dark. We must now be very observant. There's only a subtle difference between the shadows and the halftones. The rule here is very careful observation. The bishop's gray hair is not just a mixture of Black and White, which would yield a leaden color. Instead, it is warmed with Dark 1 in the shadows (B).

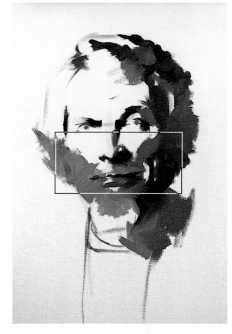

Halftones in Lower Third of Face

Most of the tones in the lower third of the face are halftones. Here they're warm and ruddy (although often on men's faces they're cool, suggesting the beard beneath the surface of the skin). The goatee now becomes part of the lower third of the face and is not really regarded as hair at this point. Use a warm Neutral 7 for the shadows and Neutral 5 for the halftones to paint the goatee. Here I keyed in some darks around the mouth area to keep it from "getting away."

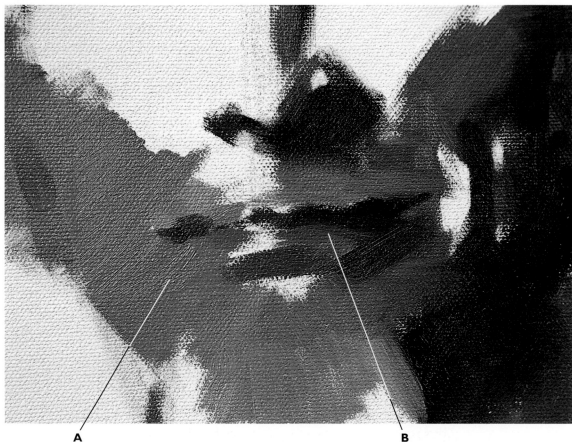

A B

I must stress over and over again the importance of simplification throughout these steps. Cover much of the lower third of the face with a large, warm grayed mixture of Halftone 2 and Cadmium Red Light (A), ignoring the multitude of small details. Add Dark 1 under the lower lip, place a warm halftone on the lower lip using a mixture of Burnt Sienna and Cadmium Red Light (B) and add White to this mixture on the light side of the lip. Strive for a unified look to this area—with no details.

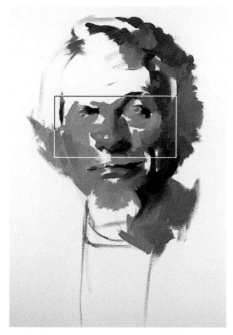

Halftones in Central Third

The central third of the face is usually a warm band of color. The nose is often quite warm and ruddy, since the blood vessels at this part of the face are close to the surface, but exercise caution. Overdoing the warmth here can be unflattering. Notice that I tried to merge the warm colors in a horizontal direction across the face.

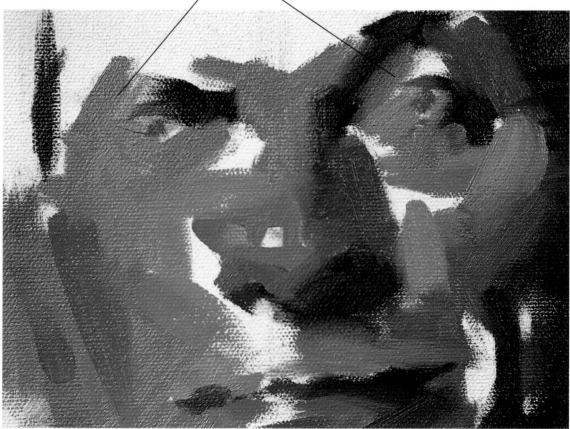

Here you can see that I've left the highlight on the end of the nose as white canvas for now. The highlight occurs at the point at which the underplanes of the nose meet the vertical planes. Placement of this highlight, which takes place with more precision in a later step, is crucial to the likeness. Notice the right side of the nose is a plane almost in shadow and the halftone is quite dark. The left side of the nose is perhaps the most intense halftone on the painting. Work on the eye sockets using a neutral tone (Neutral 5 plus Neutral 7) plus Alizarin Crimson (A). Again, remember it's simplification we're after here. Deliberately avoid details.

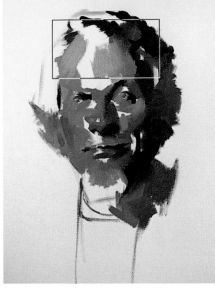

Halftones in Upper Third

Again, strive to simplify the tones on the upper third of the face. The shadow side is a mixture of Halftone 2 plus Cadmium Orange (A). It's a warm, almost golden tone. On the other side of the face, use a mixture of Light 1, Cadmium Red Light, Yellow Ochre plus Neutral 5 to gray this mixture way down (B). This is a complicated mixture, but the results state all the tones on the forehead.

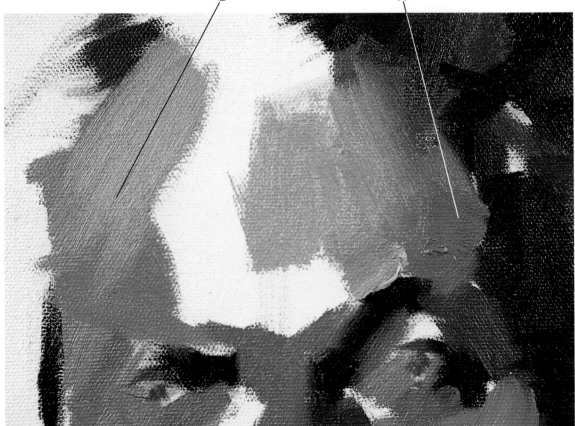

For the moment, ignore the eyebrows, and merge the hair into the forehead tones. In this step you must record the tone in the center of the forehead, even though it is really a light tone rather than a halftone.

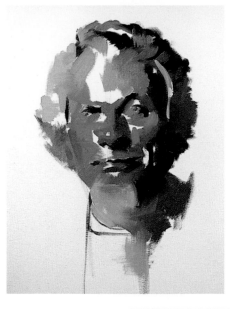

Halftones in Hair

The halftones on the hair provide the "setting" for those on the face. Although I didn't include a background tone here, I usually do so at this point so I can keep my edges soft and merge tones together.

Include additional halftones in the hair at this stage. Again, edges are softened and merged wherever possible. The edges where the hair and flesh meet must be absolutely soft, particularly in this case with the hair flowing over the forehead.

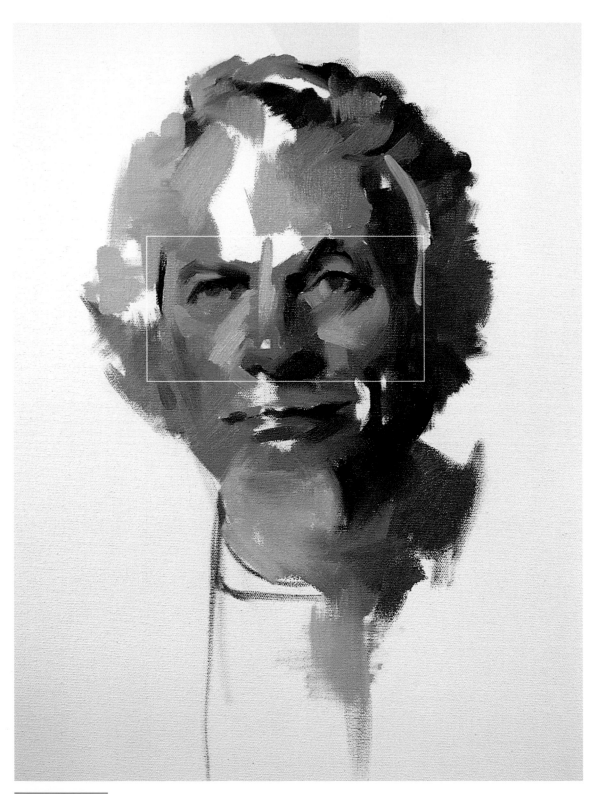

Lights in Central Third

Mix Alizarin Crimson and White for the lights on the central third of the face. This relatively cool mixture ensures the ruddy warm color isn't too powerful. Notice the direction of the forms and of the light in this area of the face. The light travels along the form.

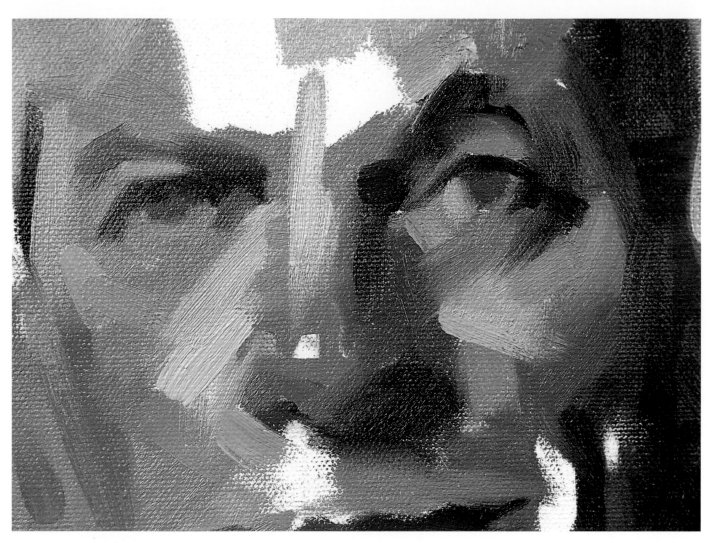

Close-Up of Step 14

I added a tentative statement of the tonal details in the eye areas, the iris, the so-called "whites," etc. Introducing these forms fully states the lights and covers all unpainted areas. Soften some definition of the darks now. Make a general statement of the eyebrows, and indicate the reflected light on the side of the face. Notice how expressive the light between the eyebrows is.

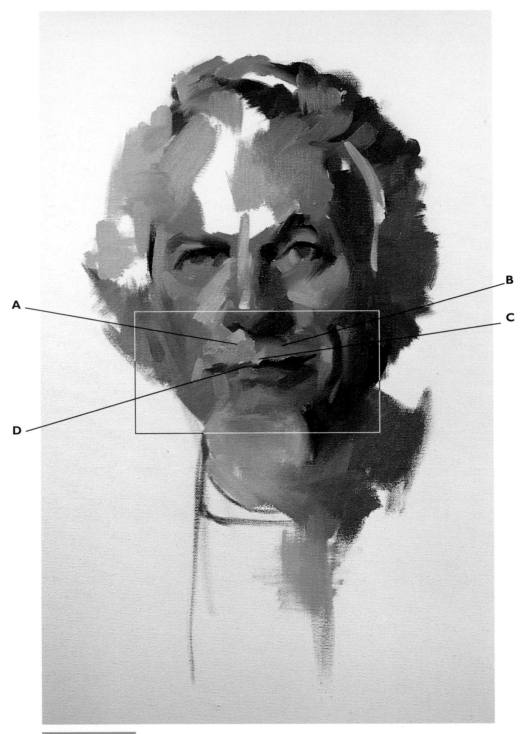

Lights in Lower Third

For the lights on the mustache, use a mixture of Neutral 5 warmed with Halftone 2 (A). Note the subtle difference between the light and halftone sides of the mustache (A, B) and the interesting little light that defines the upper lip below the mustache (C). The lower lip area in light is a pure mixture of Alizarin Crimson and White (D).

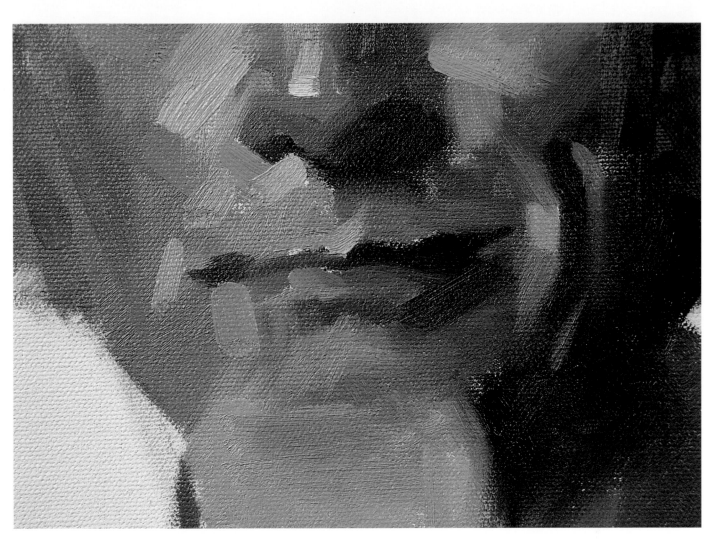

Close-Up of Step 15

At this point there are few hard edges in the painting. The major exception is the light on the fold of flesh on the right side of the face near the mouth. It's as light here as anywhere on the forehead but looks even more so because it's juxtaposed with much darker tones. To keep it from becoming too harsh, add transition tones at the upper and lower ends of this light area. The areas around the mouth are the most difficult and yet most important in giving your subject expression and personality. The lightest light on the flesh is the area just under the nose on the left side.

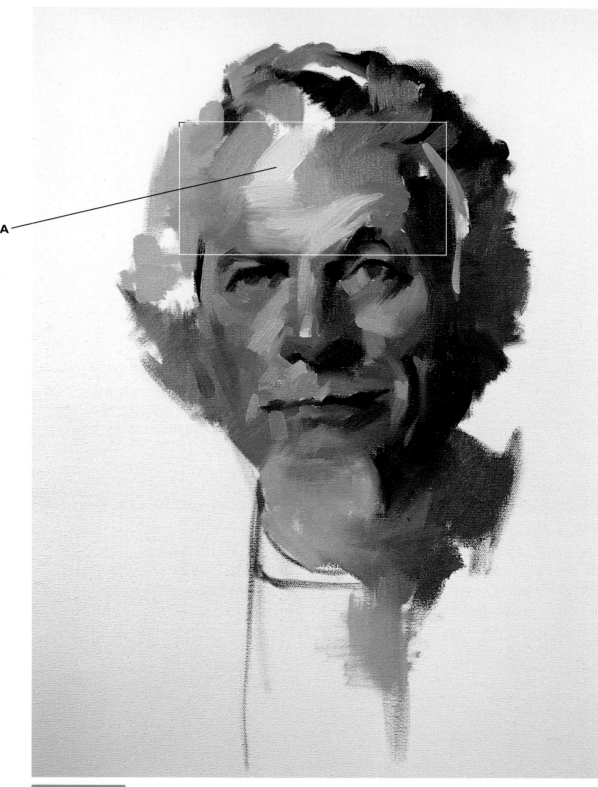

A

STEP 16

Lights in Upper Third

Use a no. 6 filbert brush loaded with a rich impasto mixed from Alizarin Crimson, Cadmium Yellow and lots of white for the lightest lights on the forehead (A). Proceed downward with the form, adding color.

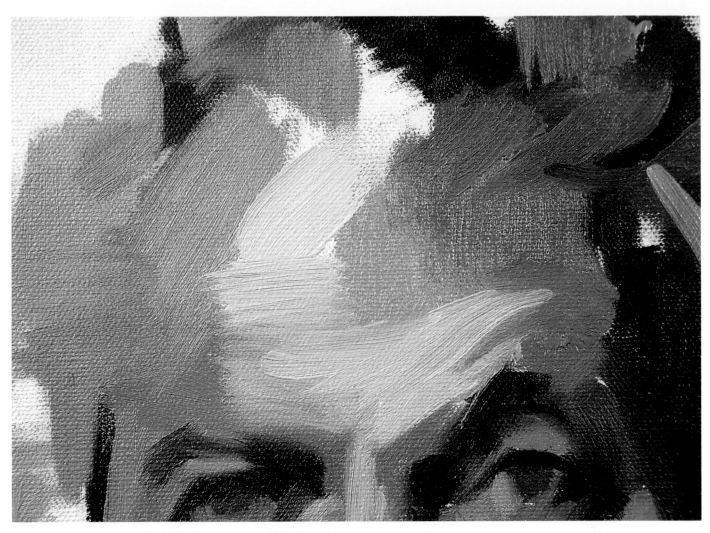

Close-Up of Step 16

Notice how I swept up the forehead along the frontal muscles that are lifted high over the bishop's left eye. This stroke is of utmost importance to the expression of urbane amusement that I was trying to record.

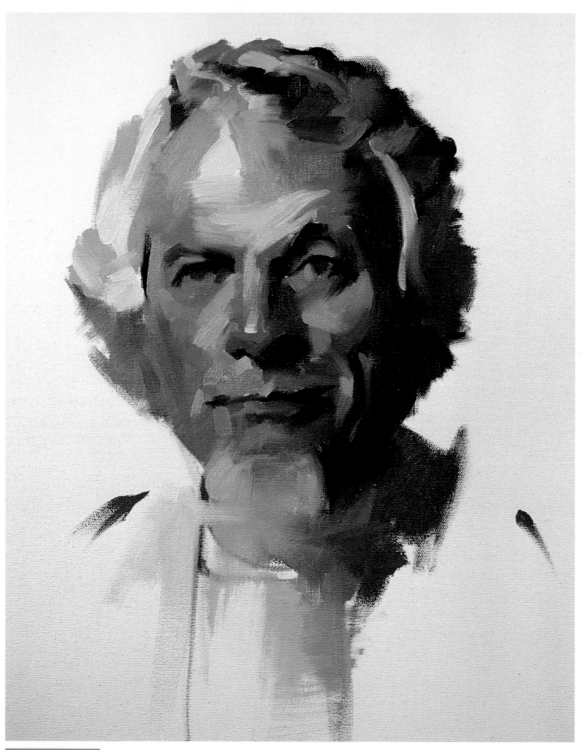

STEP 17

Lights in Hair

Using the same brush as on the forehead, add Neutral 3 to the mixture and move, flow and merge into the light tone on the hair that comes across the forehead. You can merge some edges on the hair into the forehead with your fingers rather than the brush. Add lights to the beard and merge them into the lights on the vestments. Include a few details on the garments now.

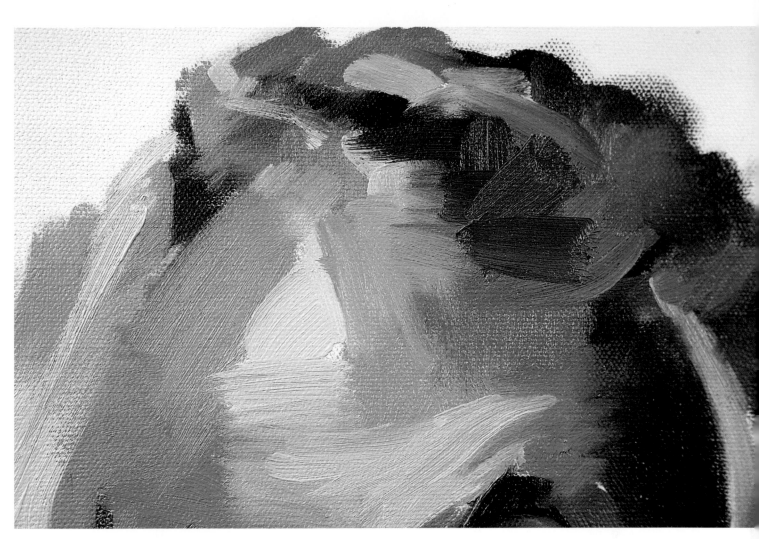

Close-Up of Step 17

Notice how the light falling on merging lights and half-tones creates movement and flow of forms. Boldly stating the light falling across the forms is one of the most exciting—and enjoyable—parts of the painting.

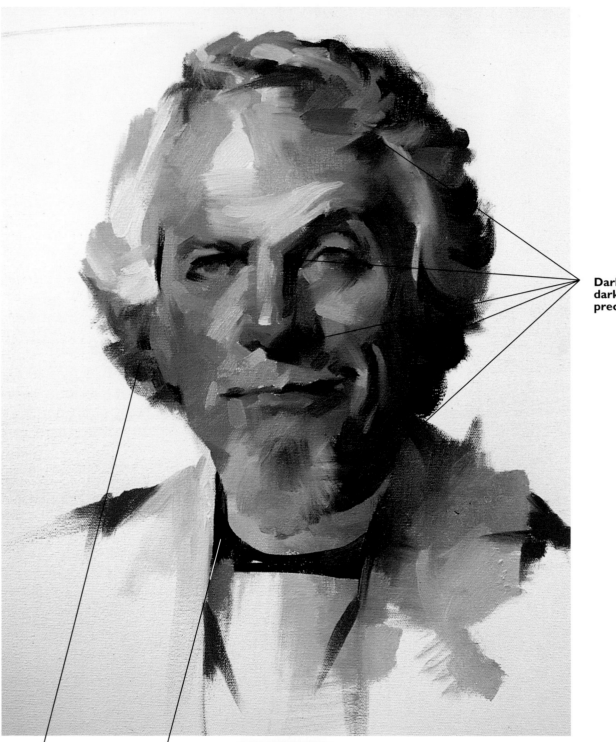

Darks restated darker and more precisely

Darks restated darker and more precisely

Dark added to garment.

Restate Darks

Now we begin the serious work of restating everything we've recorded. Before starting this work, take a break and come back with a fresh eye. I went over all the dark areas in the painting, large and small, making careful new judgments since other tones were now in place. The darks on the neck define the chin line. The darks in the hair on the shadow side go much darker, giving the hair more character. I like to use my thumb as a brush to soften and merge edges through much of this step.

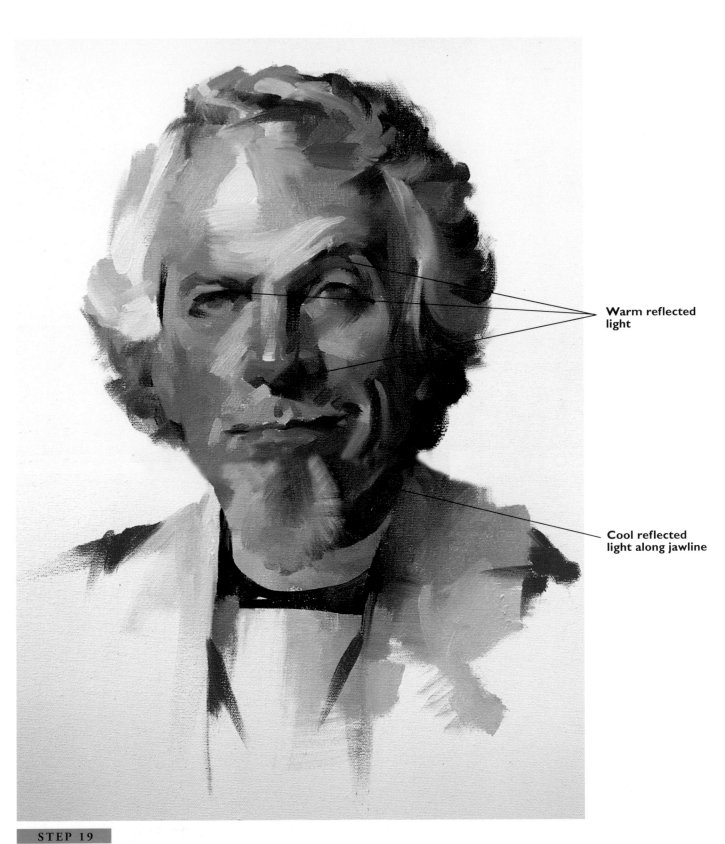

Warm reflected light

Cool reflected light along jawline

Introduce Reflected Light

The cool reflected light on the chin is a mixture of Viridian and neutral "mud" (the combination of previous mixtures from my palette). It also runs along the shadow side of the face. Indicate warm reflected light in the eye sockets and under the nose on the right side nostril using Cadmium Orange mixed with Dark 1.

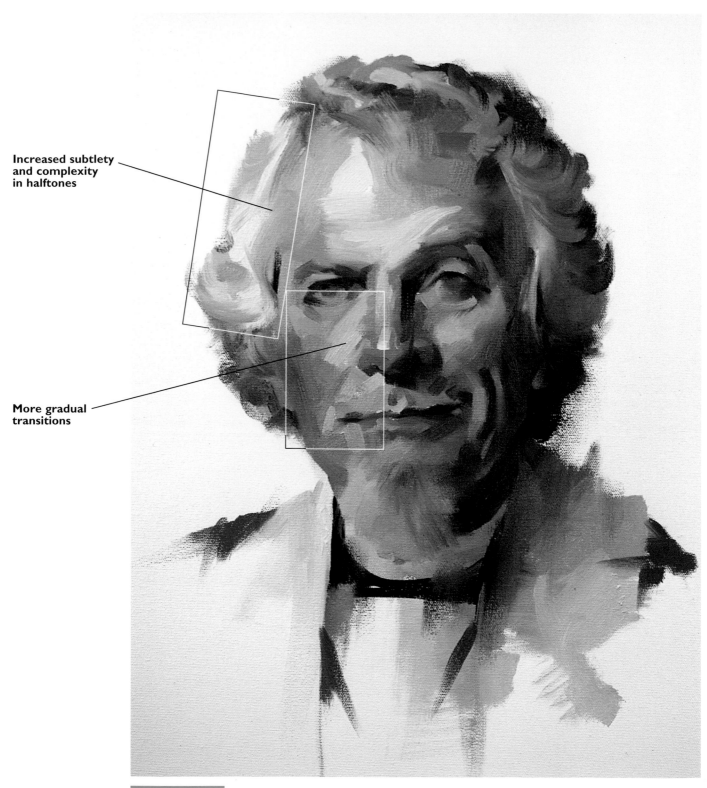

Increased subtlety and complexity in halftones

More gradual transitions

STEP 20

Restate Halftones

Restating the halftones is the longest and most difficult step. It's critical to draw with your brush the many small halftone forms that create the character and personality of your sitter. It's difficult to give precise directions at this point. This is where the intimate expression of the artist's and sitter's personalities come together. The best advice I can give here is: Observe closely!

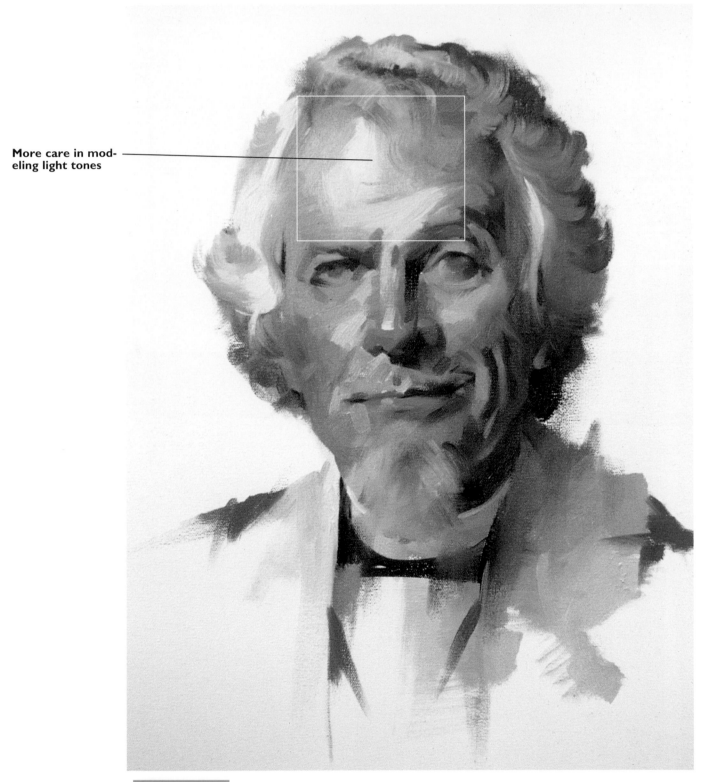

More care in modeling light tones

Restate Lights

Restating the lights is another very important step, but not quite so difficult as the previous one because there are far fewer light tones to record and correct. Again, it's difficult to give precise directions as the physical and spiritual likeness of the subject becomes more particular. Two points to always remember: (1) Observe carefully and (2) Every stroke is a drawing stroke!

Model Eye Area

Now, before we start the details of the eyes, begin the final modeling of the eye area. Restate the small darks, halftones and lights in the eye area just as you did on a larger scale on the overall painting.

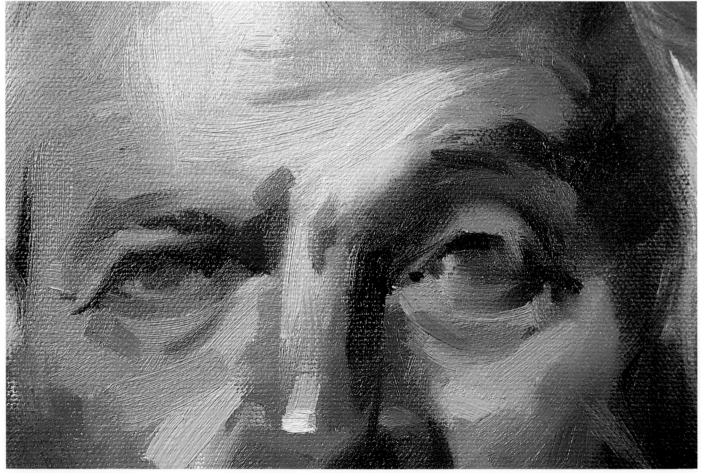

Particularize the subject's eyes, unify forms in the area and soften edges to prepare for the final details.

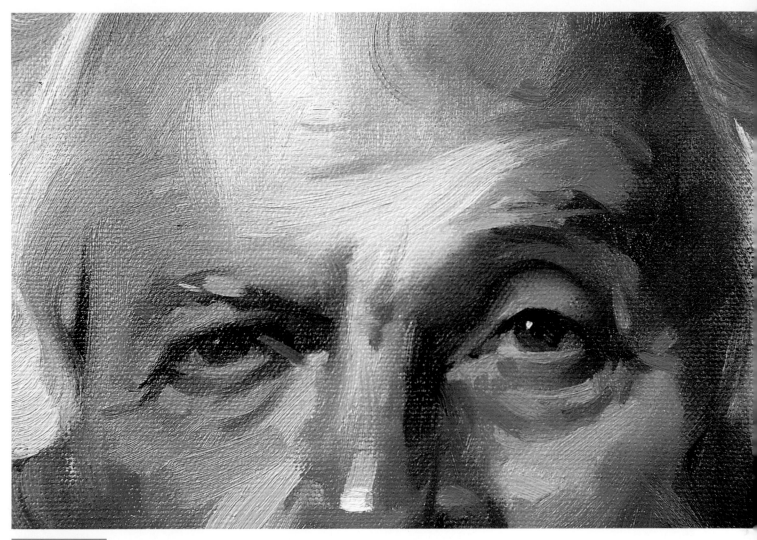

Paint Eye Details

To paint eye details, I switch to my sable brushes. The irises of blue eyes aren't bright blue, but a gray mixture of Black and Ultramarine Blue. Only the pupils are pure Black because they represent the complete absence of light and color. First, darken the upper third of the iris, where the light is blocked by the upper lid, using additional Black in your mixture. Next, record the darks under the upper eyelids. Throughout these detailed steps, strain to observe carefully and record accurately. The "whites" of the eyes are really four planes turned at differing angles to the light source, and they aren't white at all but values of neutral gray. The whites often have a hint of flesh tone in them. Record the highlight on the rim of the lower eyelid using a mixture of Cadmium Red Light and White. The catch light—the direct reflection of the main light source—is at the "eleven o'clock" position here. Paint it with pure White mixed with a touch of Ultramarine Blue.

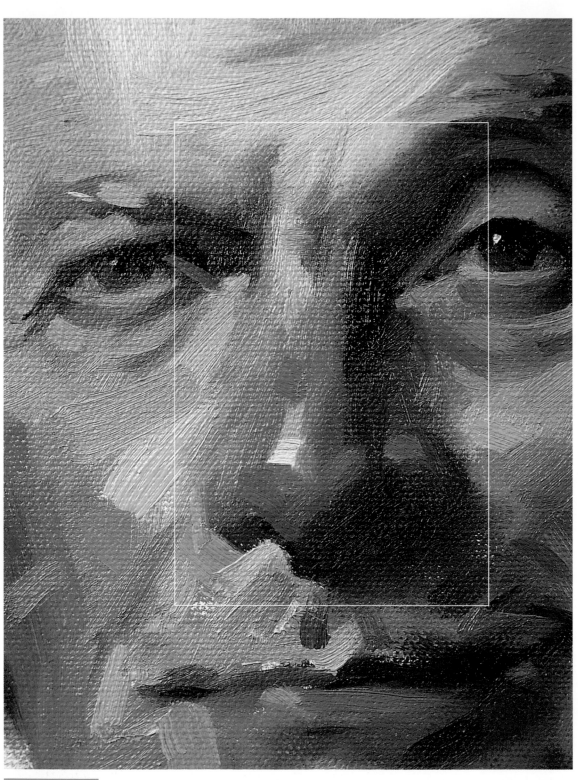

Model Nose Area

Model the nose area by restating the small darks, half-tones and lights in the specific area of the nose while continuing to relate it to the warm band of color across the central third of the face.

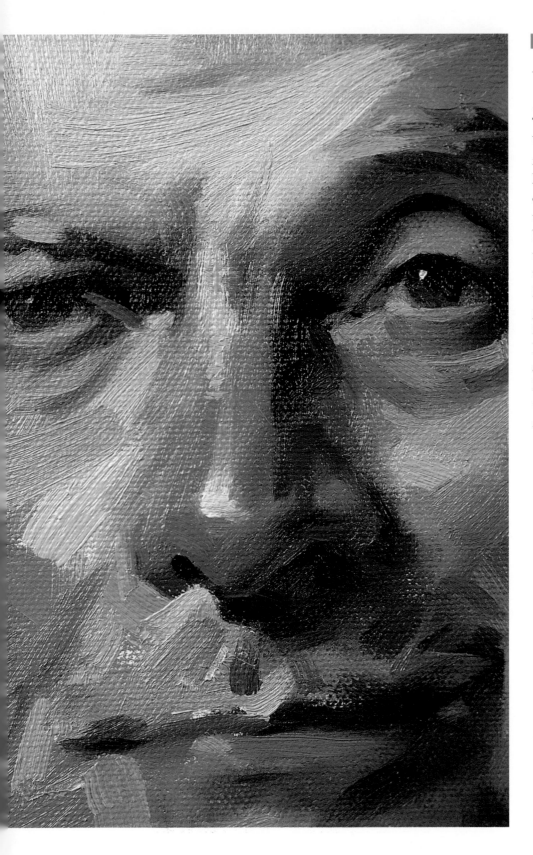

Paint Nose Details

For the details of the nose, I once again reach for my sable brush. The nostrils are a mixture of Burnt Umber and Alizarin Crimson, with the nostril on the light side containing a little more Alizarin Crimson or a touch of Venetian Red. Once again, tend to the catch light on the tip of the nose, but this time with a brushload of a mixture of White, Alizarin Crimson and a touch of Yellow Ochre. The catch light is placed at the bottom edge of the front plane of the nose at the point at which it meets the bottom planes of the nose. It travels up the nose slightly. This stroke is of utmost importance since its high value (in contrast to the darker tones around it) is what creates the illusion of the third dimension.

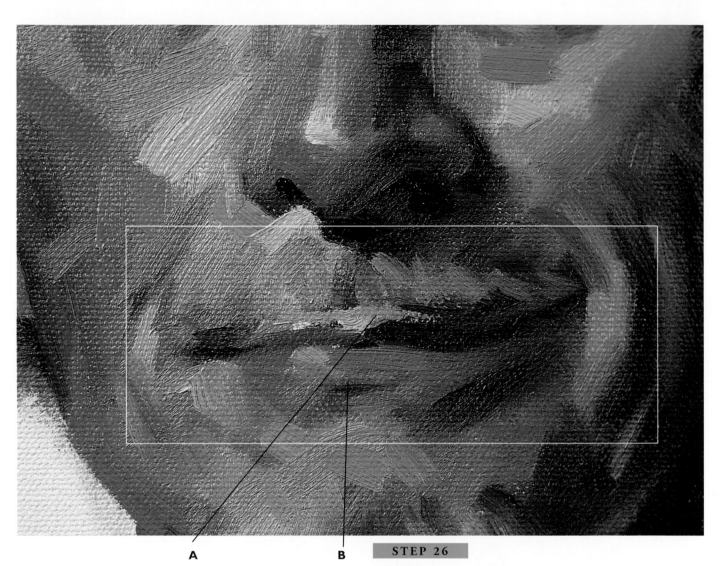

A B

Model Mouth Area

I return to my bristle brush to model the mouth area before going back to the refinement of my sables. Once again, it's careful observation of the small darks, halftones and lights in this area that, if properly recorded, create the character and personality of the sitter. Notice the modification of the highlight (A) on the upper lip area and the reshaping of the small form in the area just below the lower lip (B). These tiny strokes are extremely important in creating the character in the portrait.

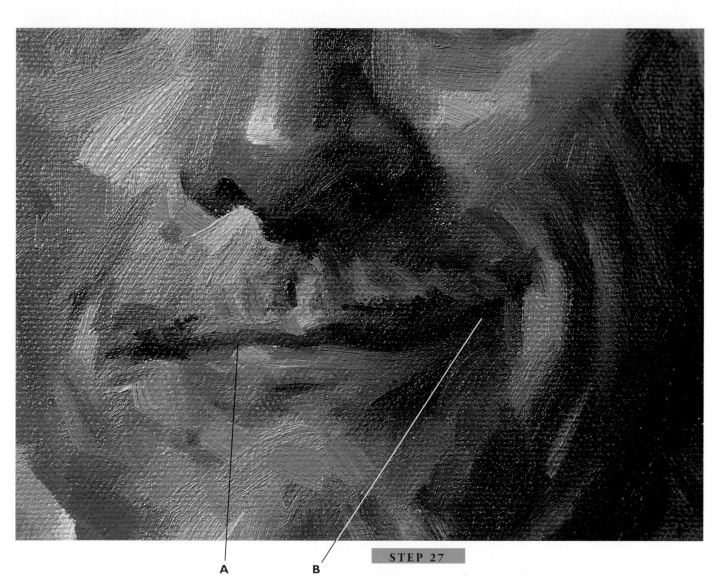

A **B**

Paint Mouth Details

Back to my sables to record the subtle details of the
mouth. The mouth is always the most difficult feature
to paint because it's mobile and can, of course, only be
recorded in a painting in one of its many positions. Note
the stroke that delineates the separation of the lips and
suggests a slight smile (A). Also notice the small dark ac-
cents at the corners of the mouth (B).

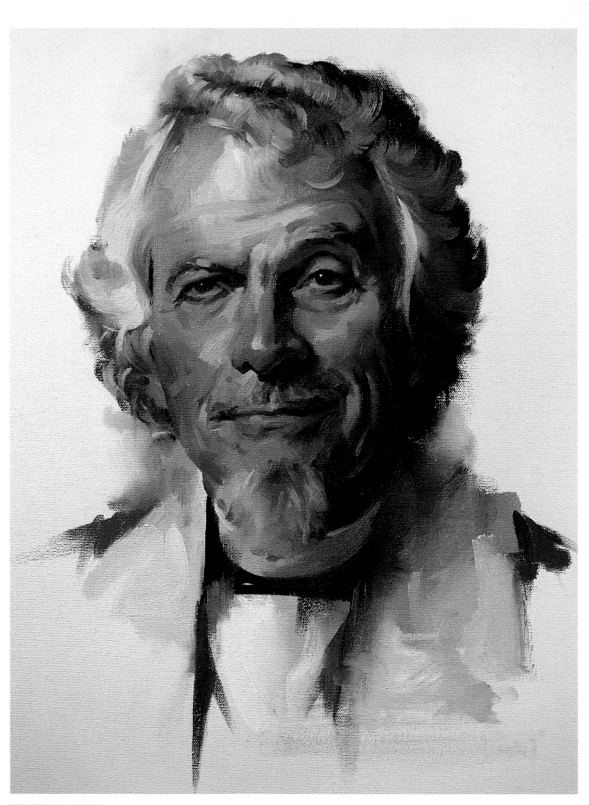

Paint Hair Details

Now you can finally create the illusion of texture in the hair. Have fun using your fan brush here and there to suggest wispy swirls of hair. Don't overdo this step, or it will look gimmicky and facile.

Close-Up of Step 28

The basic architectural integrity of the hair that we achieved by bold blocking-in can be lost entirely by too many soft touches at this step. Stop too soon rather than too late, or the hair becomes fussy and overworked.

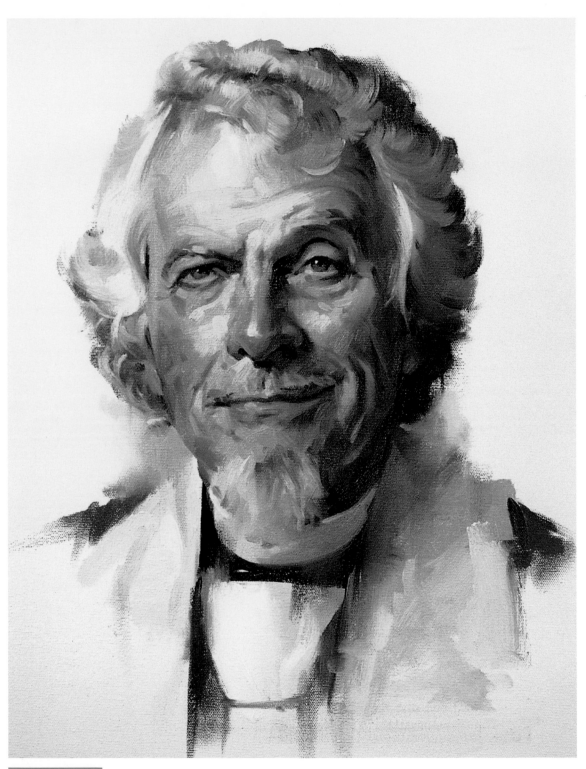

Finishing Touches

Include some accents in the forehead creases and an accent on the collar. Add the white apron on the garment using pure white paint, which makes it whiter than the canvas. Add some background tones to merge with the edges of the hair and garment.

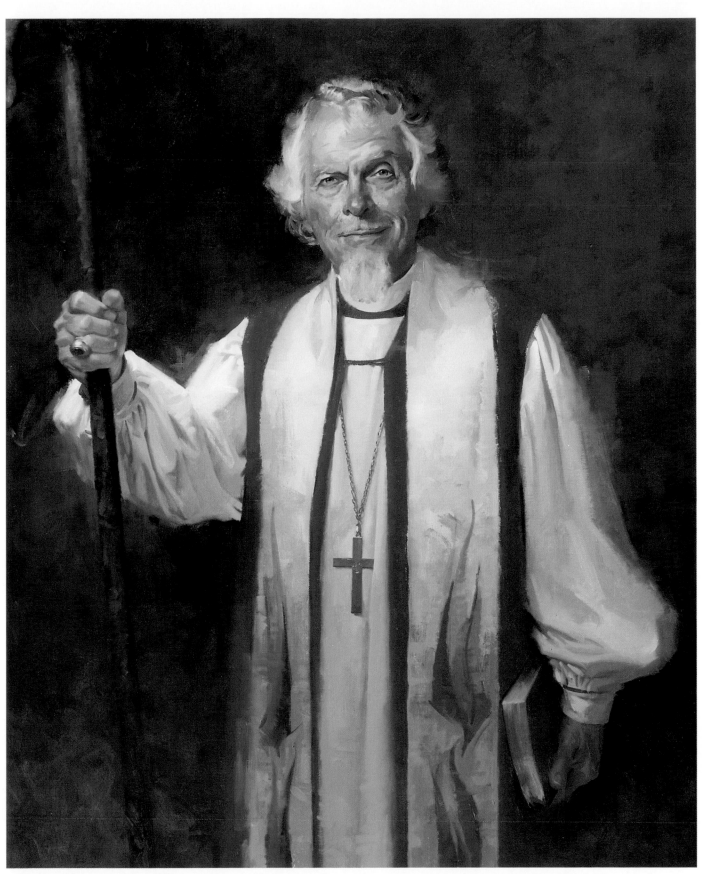

THE VERY REVEREND NED COLE
Oil on canvas, 42" × 50" (107cm × 127cm)
Collection, The Episcopal Church, Diocese of Central New York
Syracuse, New York

Nigerian Lady

This subject offered two special challenges: first, to demonstrate that a palette formulated for Caucasian complexions would work as well for a dark-skinned subject; second, to incorporate the effects of an unusually complex lighting pattern. I think you will agree that the twenty-nine steps I recommended to you in the previous demonstration are a good, methodical way to proceed. It is important to keep in mind that, while the emphasis in these captions is on describing the color mixtures used, the color is a secondary consideration to the all-important one of drawing. Successful portraiture is built on a foundation of good drawing!

Establish Size and Placement

Make these strokes with a no. 4 bristle filbert brush using Neutral 5. The stroke at the top of the canvas indicates the highest point of the hair. Place it approximately 2¼″ (5.7cm) from the top of the canvas. The lowest stroke indicates the bottom of the chin, exactly 10¾″ (27cm) below the top stroke. The stroke on the left indicates the farthest point to the left on the hair, and the stroke on the right indicates the farthest point to the right. The distance between those two points should be approximately 7½″ to 8″ (19cm to 20cm). These four strokes are of utmost importance—take your time when establishing them.

Block In Basic Shapes

Working from the outside of the shape, make two diagonal strokes for the shape of the top of the hair and two diagonal strokes to indicate the approximate shape of the lower portion of the face and hair. Two more-or-less vertical strokes indicate where the beads form the neckline, and a couple of strokes on either side provide the approximate location of the shoulders.

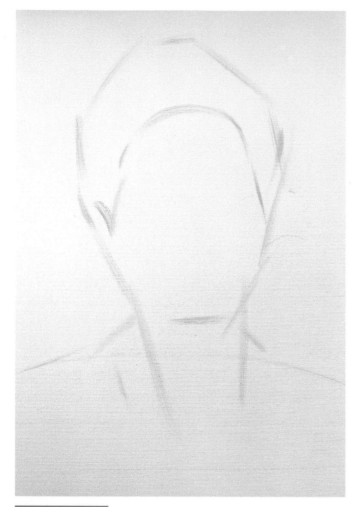

Subdivide Face Mass/Hair Mass

To show where the forehead meets the hair, draw a curving line across the top of the forehead and down the sides of the head. One little stroke indicates where the hair and the ear meet. As you do this very simple operation, have in mind the size and proportion of the shape of the face as it relates to the shape of the hair.

Establish Central Facial Axis

This step consists of just one stroke. The stroke establishes the vertical facial axis, dropping down through the middle of the features between the eyebrows, down the point where the nose attaches to the face and between the central points on the mouth. You'll see that this line curves ever so slightly to suggest the convex character of the facial plane.

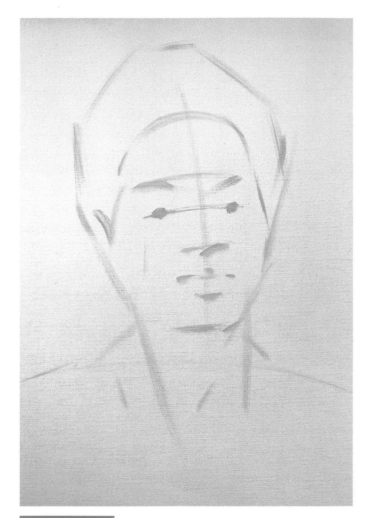

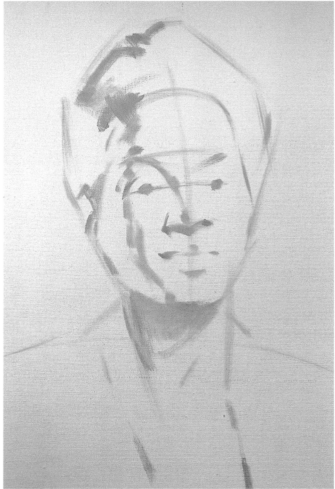

Map Landmarks

Using a no. 4 brush and Neutral 5, first establish a horizontal axis for the eyes. Every art student knows that this horizontal axis on which the irises are located usually comes approximately halfway in the face from top to bottom. In this case, you must take into consideration the rather high shape of the hair. Next, establish a horizontal axis for the eyebrows (which are very elevated above the eyes), as well as a point on which the nostrils and the base of the nose will sit, the division between the lips, the two little accents for the corners of the mouth and the cast shadow beneath the lower lip.

Divide Light and Shade

There are two light sources in this portrait. The main light is in front of the subject and slightly to the right. You can discern the position of the source of this light by the shape and placement of the cast shadows beneath the nose and chin. In addition, there's a strong secondary light source coming from the left that creates areas of light along the side of the face and on the ear, neck and hair as well as on the beads and garment. So, the shadow tone areas on this painting occupy smaller spaces than they would on a coventionally lit portrait. There's a pattern of darks here that works its way down the face from top to bottom, between the main front-lighted planes of the face and the strongly sidelighted planes of the side of the face. The largest area of shadow is the cast shadow on the neck.

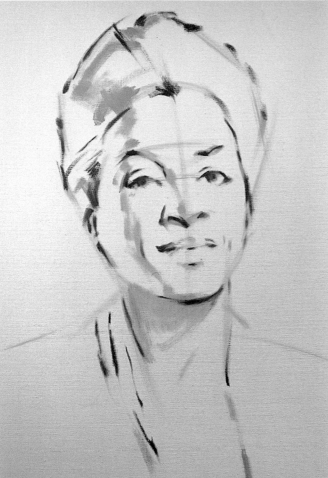

Define Significant Landmarks

Now take a smaller brush, a no. 2 bristle filbert, with which you can make a more precise mark. And instead of the Neutral value 5, use Neutral 7, which is a darker neutral shade. Go back over your drawing and state a number of details more specifically, more precisely and more carefully—the pupils of the eyes, the curve of the eyelid, the drawing of the eyebrows, the nostril, the division between the lips, the accents at the corner of the lips, the curve of the chin, some of the details of the ear, some of the important forms in the hair, some of the form in the beads, etc.

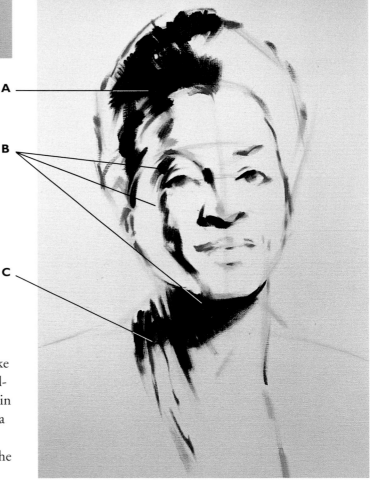

A

B

C

STEP 8

State Shadows

Our goal in this step is to state all the shadows. Take a large brush (a no. 6 or perhaps a no. 8 bristle filbert). Use pure Ivory Black for stating the shadow tones in the hair (A). For the shadow tones on the face (B), use a mixture of Dark 2 deepened with Burnt Umber. Then, darken Burnt Sienna with a touch of Burnt Umber for the dark tones on the beads and garment (C).

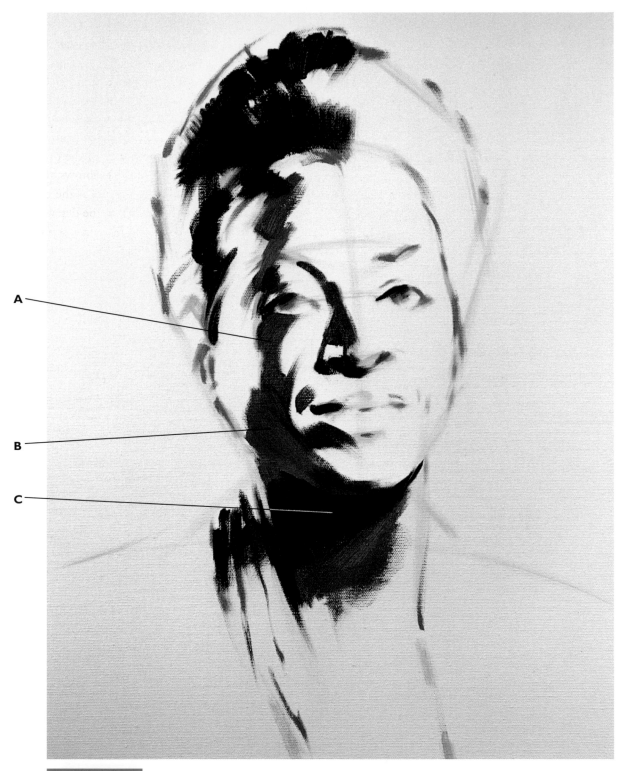

STEP 9

Transition Halftones

The so-called transition halftones are halftones that lie along the edges of the dark and provide the transitions from the darks into the lights. There in the central areas of the face, use Dark 1 and add a bit of Chromium Oxide Green (A) in certain areas and a touch of Venetian Red in others. Down on the left-hand side of the jaw area, add a bit of Alizarin Crimson (B), and then add a touch of Cadmium Red on the neck (C).

Halftones in Lower Third of Face

Here, as you can see, I worked with a large brush in a sort of crude, simplified way to block in the major halftone shapes. Dark 1 is the basis for most of the colors. Where they're cooler, add a touch of blue or a touch of green. Where they're warmer, add a touch of Venetian Red or Burnt Sienna. The lips are Alizarin Crimson and Venetian Red plus, in some of the darkest tones, Burnt Umber (A). That highlight on the lower lip is Alizarin Crimson and White (B).

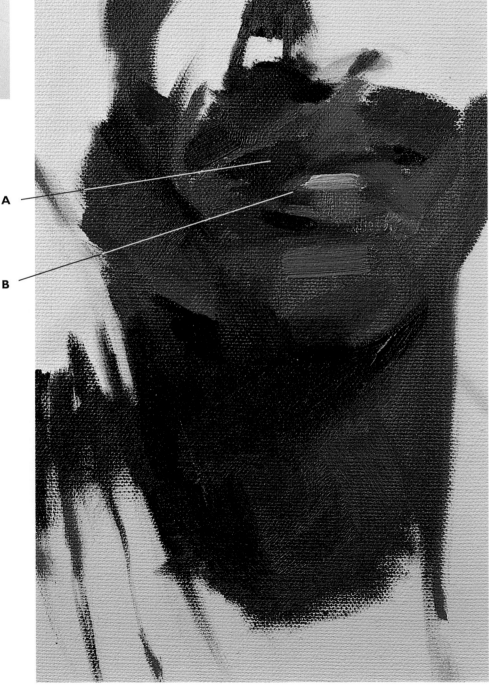

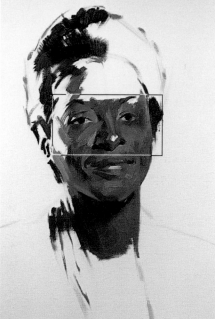

Halftones in Central Third

In the area from the eyebrows to the base of the nose, there are some interesting, perhaps unexpected, variations in the colors. For example, in the areas of the eyelids we see some coppery tones, where I added a touch of Cadmium Orange to the dark colors for variety (A). In the area of the nose and between the eyebrows, Alizarin Crimson and Ultramarine Blue add a lavender cast to the color (B). The warm highlights on either side of the nose have Venetian Red and Cadmium Red introduced into them to create interest (C). Along the extreme right-hand edge of the head, between the cheekbones and the hair, suggest the cool, bluish reflection that adds interest along that side of the face (D).

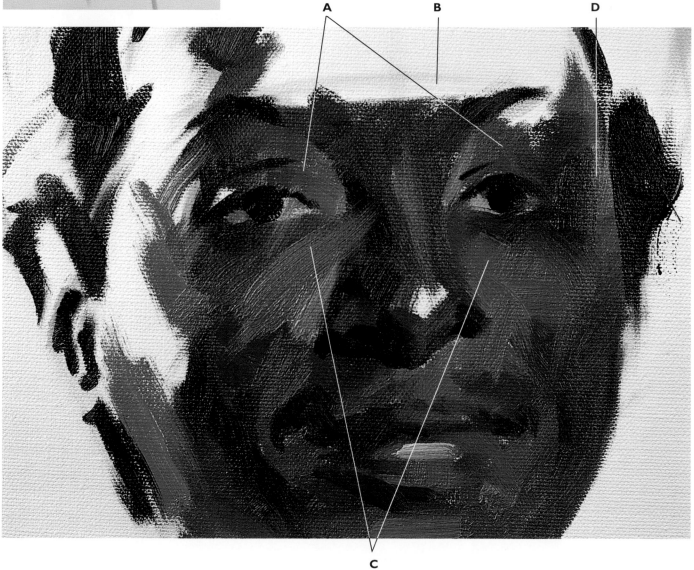

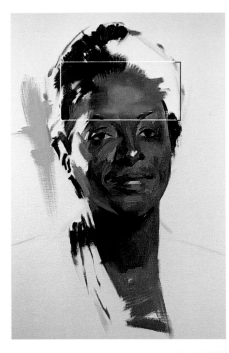

Halftones in Upper Third

This step is a very simplified bit of painting. Many of the tones are basically Dark 1, some with green added for a rich grayness (A). In the center of the forehead, use Yellow Ochre and a touch of Neutral 7 to create a somewhat neutralized light tone (B).

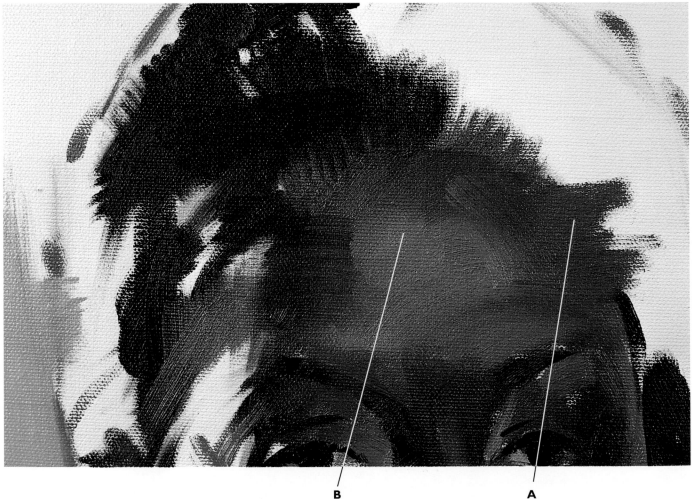

B A

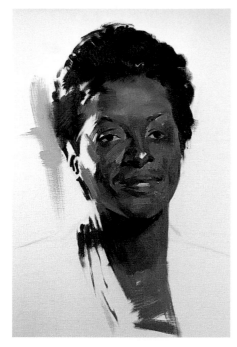

Halftones in Hair

The halftones in the hair are so dark and so close in value to the dark tones in the hair that they're hardly visible in the illustration. In actual fact, I used a certain amount of Neutral 7 in some areas for coolish halftones, particularly along the edge of the hair (A). I also introduced some Burnt Sienna and White for warm halftones (B) right through the central portion of the large mass of the hair above the forehead.

A B

Lights in Central Third

We observe that the lightest highlights are surprisingly cool here, even bluish. For example, the highlight on the tip of the nose you can mix from Ivory Black and White (A), creating a beautiful cool grayish tone, enhanced with Ultramarine Blue, if necessary. Notice that the highlights on the eyelids are grayish—Neutral 7 and Neutral 5 are helpful here (B). Mix some of the warm tones by adding Venetian Red and Cadmium Red into your basic dark tone mixture (C). In the area between the upper lip and the nose there are beautiful cool grayish-blue highlights (D). Throughout the painting of this portrait, I considered Dark 1 as my basic color.

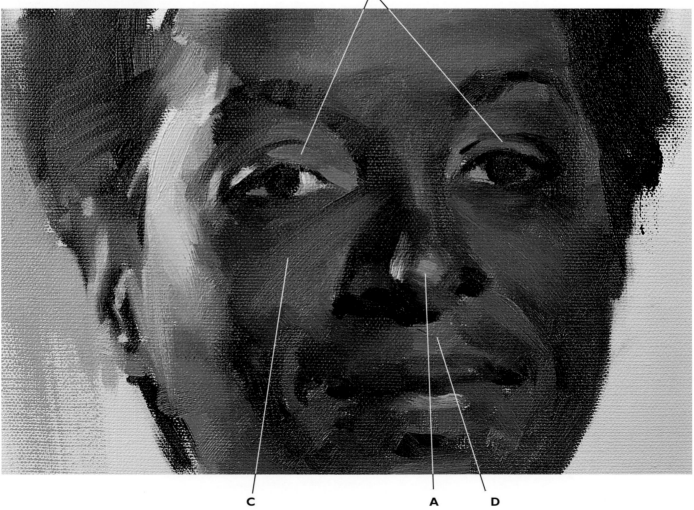

Lights in Lower Third

Dark 1 with some Neutral 5 gives the cool highlights. Where the lights tend to be warm, a touch of Burnt Sienna or Venetian Red will do. For centuries the tradition in oil painting has been to paint the darks rather thin and the lights in an opaque impasto. Place the final highlights, such as the one on the chin, with a single stroke and allow it to remain unaltered. This gives a crisp, impressionistic surface quality to the painting.

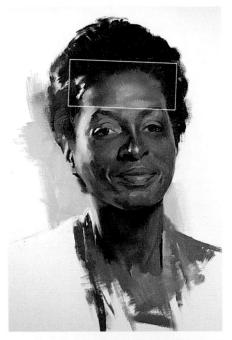

Lights in Upper Third

Mix Neutral 5, perhaps with a touch of Neutral 3 added to brighten it still further (A), for the very cool highlight in the center of the forehead. The strong secondary light on the side of the forehead is White and Ultramarine Blue, neutralized with Neutral 7 (B).

Another important tradition of painting is that the brushstroke "follows the form." This is particularly important in the impasto highlights on the forehead.

A

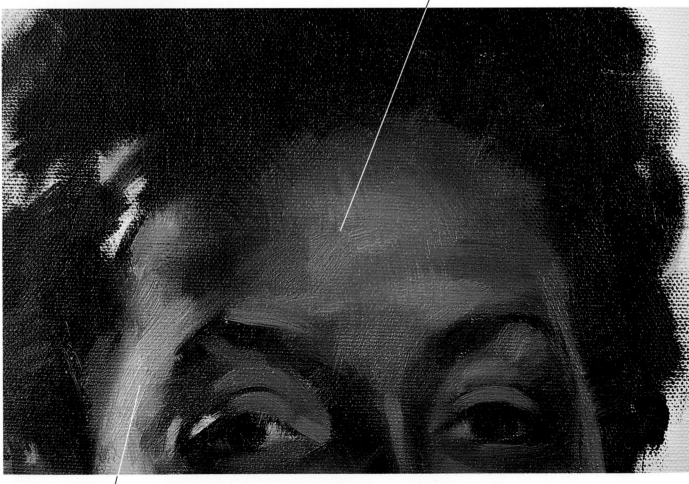

B

Lights in Hair

There are two cool lights along the upper edge, where the secondary light is strongly visible. To achieve this effect, add both blue and green to white and then mix into the dark hair (A). Achieve the warm color through the central portion of the hair, above the forehead, by mixing a touch of Burnt Sienna and White together and then mixing it into the black tone of the hair (B). This interplay between the warm tone of the main light and the cool tone of the secondary lights gives vitality and interest.

A **B**

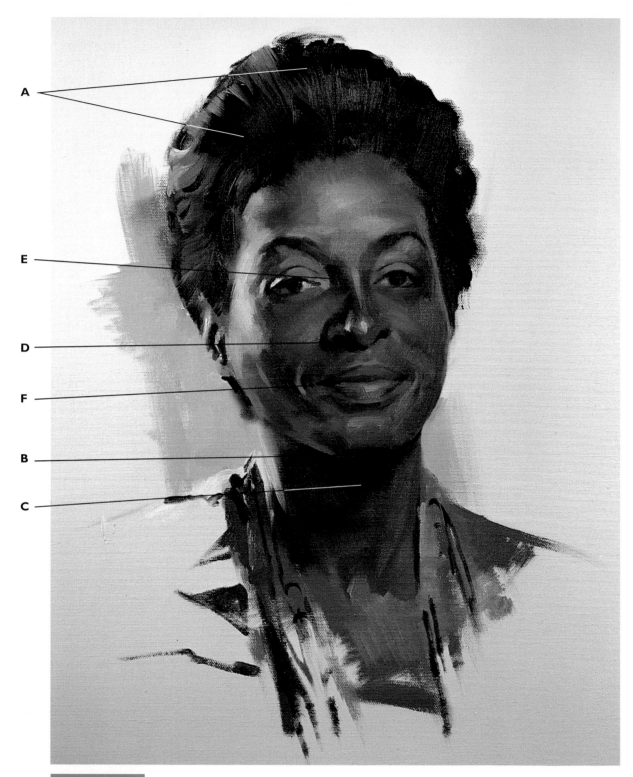

Restate Darks

At this point go back and restate almost everything you have done. Starting with the darks, specifically the darks in the hair, use pure Ivory Black (A). Restate the dark under the chin (B) and the dark on the neck (C). Use Burnt Umber and Alizarin Crimson, and make those darks fresh and crisp. Using a small filbert, restate the dark under the nose (D) and in the corner of the eye socket (E), at the corners of the mouth (F), on the beads, and so forth.

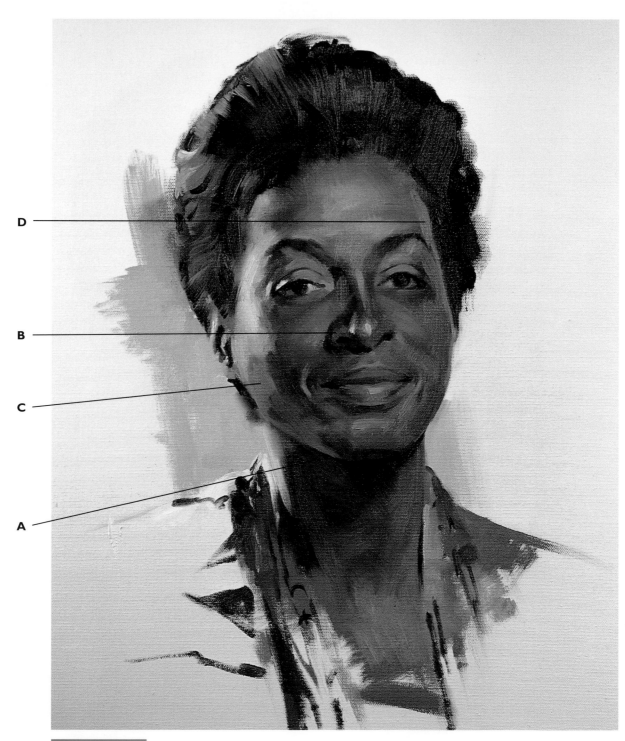

D

B

C

A

Introduce Reflected Light

The most striking example of reflected light is on the neck just below the chin (A). In this subject, that area seems to glow with a vivid, warm reddish tone. I used Venetian Red and Cadmium Red to get that effect. In the shadow on the nose (B), a rich Cadmium Red plus Cadmium Orange gives a warm, glowing look. Alizarin Crimson and White gives a slightly lavender look in the area of the reflected light on the side of the jaw (C). Notice along the right side of the model's forehead, cheekbone and neck, a beautiful kind of gray-blue tone (D). This is not really reflected light, but secondary light.

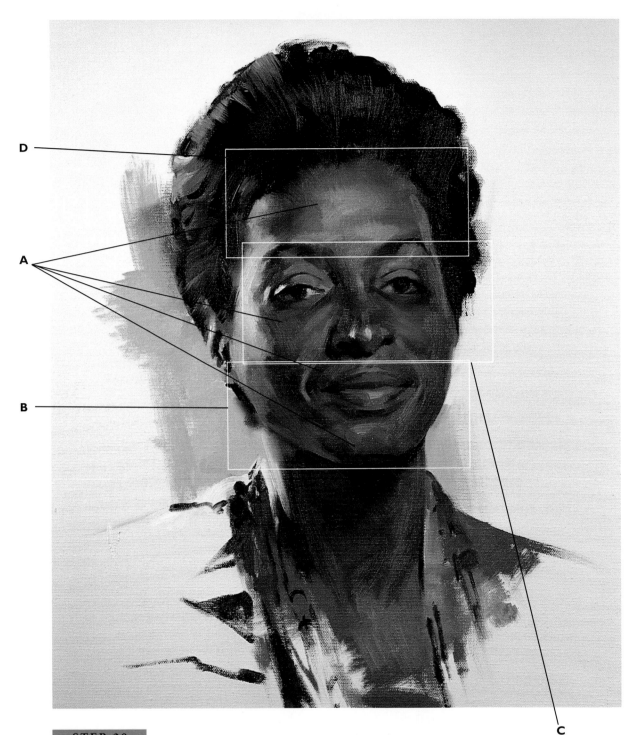

D

A

B

C

STEP 20

Restate Halftones

This may be the most important single step in painting a portrait. Certainly it's the most time-consuming. I go over the entire painting, critically comparing the subject with the painting. Start with the transition halftones (A), then the halftones in the lower third of the face (B), then the central third (C), then the upper third (D). In other words, work methodically back over the whole painting. Ask yourself: "Is this particular halftone dark enough or light enough? Is the color as intense as it should be, or should it be grayed down a little bit? How about the edge of this area—should I soften it, or should I sharpen it up a bit?"

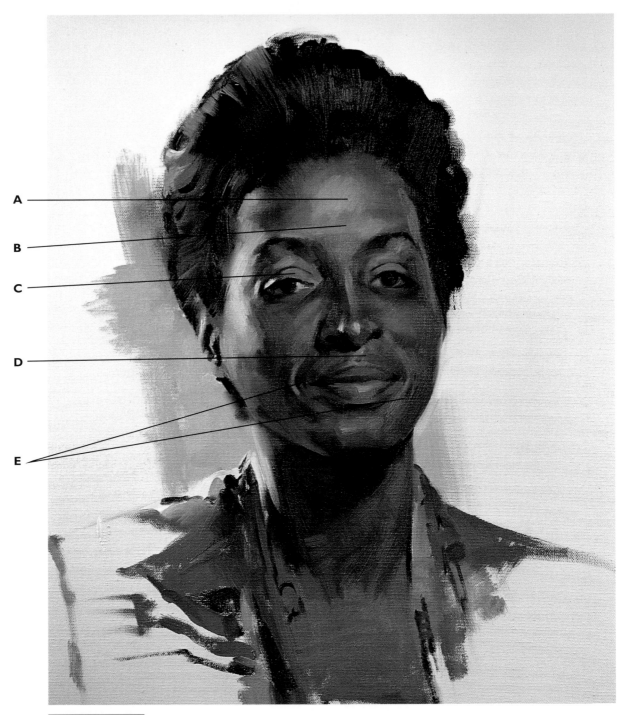

A

B

C

D

E

Restate Lights

Study the lights in the subject and compare them with your painting to see if there are ways you can make improvements. Check the light on the forehead (A), the light on the brow ridge (B), the lights on the eyelids (C), the lights above the upper lip (D), the lights on the "pillars" of the mouth—those curving shapes that give the mouth its expression (E). You can see that in this step I added quite a bit of cool light on the neck, beginning on the right-hand side.

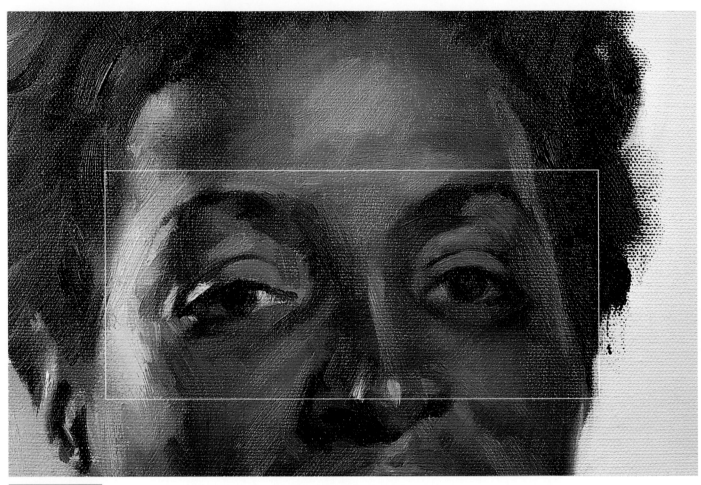

Model Eye Area

We're going to begin to particularize our portrait now. Up to this time we've created a painting thinking in terms of color and tone, and shape and edges. Now begin to think specifically of the human being that you seek to evoke, and force yourself to concentrate on specific details: the eyes, the nose, the mouth, the ears, the hair. Do each in two stages: first model the area, then paint the details. I think this routine is important. In this step, I work in the areas of the eyes, matching the tones that surround the eyes, blending them softly here and there to make the darks of the eye socket flow out into the lighted areas of the forehead and the cheeks. The eye socket is concave, but the eye itself is convex.

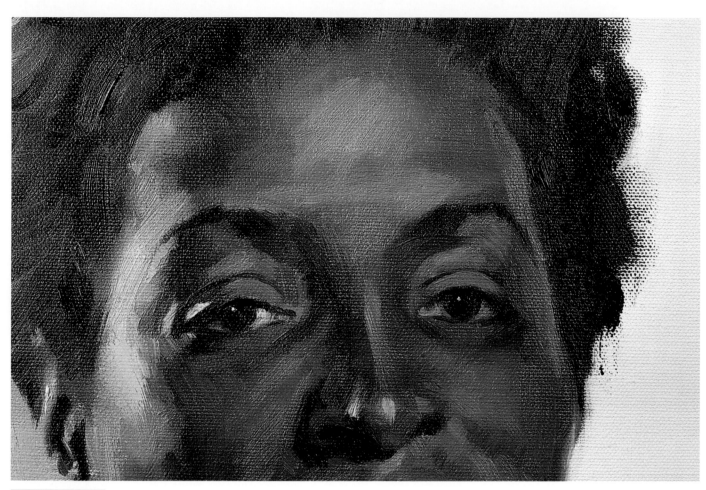

Paint Eye Details

This model's iris is an extremely dark color. Use Burnt Umber and Ivory Black, with just a touch of Burnt Sienna here and there. The eyelashes and the darkest part of the upper eyelid are essentially pure black. The eyelashes on the lower lid are Ivory Black and Burnt Umber. The whites of the eyes deserve a careful and close study. You can see that four separate tones make up the whites, two tones in each eye. The lightest area is in the eye to our left. It is approximately a value 4—slightly darker than the Neutral 3 you have on your palette. The other areas of the so-called whites of the eye are considerably darker. The highlight on the eye (the catch light) is a crisp little touch painted using a pointed sable brush with a bit of almost pure White on it. It comes right on the edge of the pupil, where the pupil and the iris meet.

Model Nose Area

The nose occupies the central third of the face. It builds out from the forms that surround it on either side—it's not a separate entity. Blend the grayish halftones that make up the side planes of the nose out into the cheeks on either side. I recommend using Dark 1 for those tones and perhaps Neutral 7. Define the cast shadows beneath the nose, shape the nostrils and place the highlights. Why are there two highlights on the nose? One comes from the main light that illuminates the front plane of the face, and the other is a spillover from the brilliant bluish secondary light that strikes the side of the face.

Paint Nose Details

Very little remains to bring the nose to completion. Take an extremely dark color on a pointed sable brush—Burnt Umber and Alizarin Crimson, with perhaps even a touch of Ivory Black to make it really dark—and define the nostril openings. Define the drawing of the nostril wing to our left with a color not as dark, mostly Burnt Umber and Alizarin Crimson. Paint in the reddish reflected light that curves around under the nostril opening. Shape the two highlights carefully.

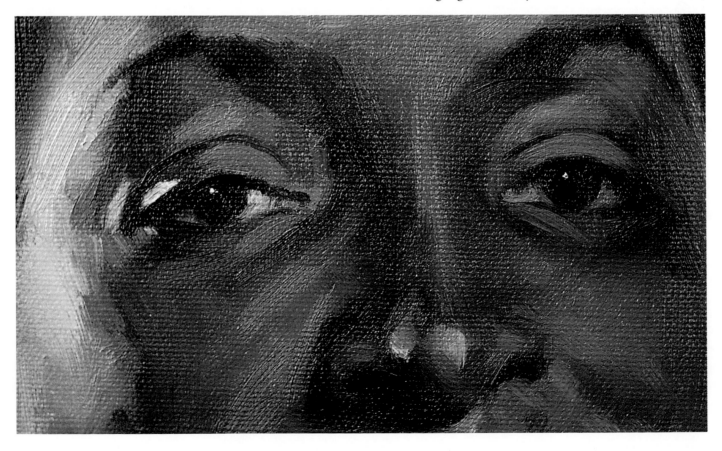

Model Mouth Area

The light is striking the "pillar" of the mouth on either side. These are the characteristic curving shapes that help give the mouth its expression. Just inside these curves on both sides are some beautiful, and I might add difficult, halftones. Dark 2 plus Viridian and Dark 2 plus Chromium Oxide Green should give you these mixtures. Some of the other tones around the mouth are Dark 1 plus Neutral 5. The cast shadow beneath the lower lip is pure Burnt Umber. Paint the lips with mixtures of Alizarin Crimson, Venetian Red and Cadmium Red.

Paint Mouth Details

Use Ivory Black and Alizarin Crimson for the accents in the corners of the mouth. The highlight on the lower lip is Alizarin Crimson and White. The highlight just above the upper lip is Chromium Oxide Green with White mixed into flesh color. The treatment of edges around the perimeter of the mouth is extremely important: In some places brush the strokes outward into the surrounding area; in other areas brush the strokes the long way, along the edge of the lip. The combination of brushing "with the form" and brushing "against the form" generally creates a lively surface interest. What you don't want is a stiff, brittle, hard, crisp painting of the mouth. You want it to look as if the lips are about to part in speech.

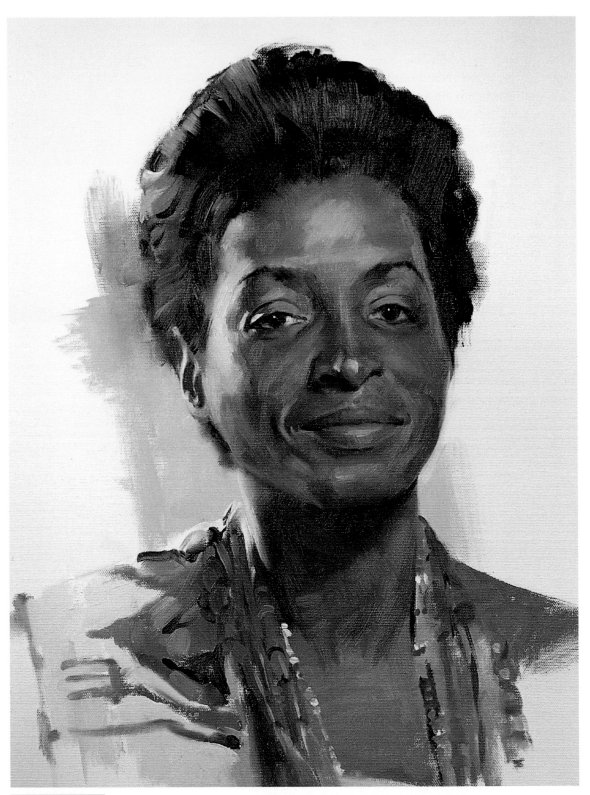

Paint Hair Details

With your smallest fan brush and pure Ivory Black, go back over the hair to redefine it. Achieve a final crispness to the shapes of the hair and the way it's brushed. Notice in the right-hand side of the painting where no background is indicated, the edge of the hair is finished off with a drybrush touch. I used my thumb to rub the paint onto the dry canvas there.

Close-Up of Step 28

The secondary light coming from the left creates a vivid light and shade pattern that relates only to this particular portrait. The highlights on the ear are white and blue, and the darks are a rich, warm reddish mixture of Venetian Red and Burnt Umber. The pinkish tone on the earlobe is Alizarin Crimson, Neutral 7 and a touch of White.

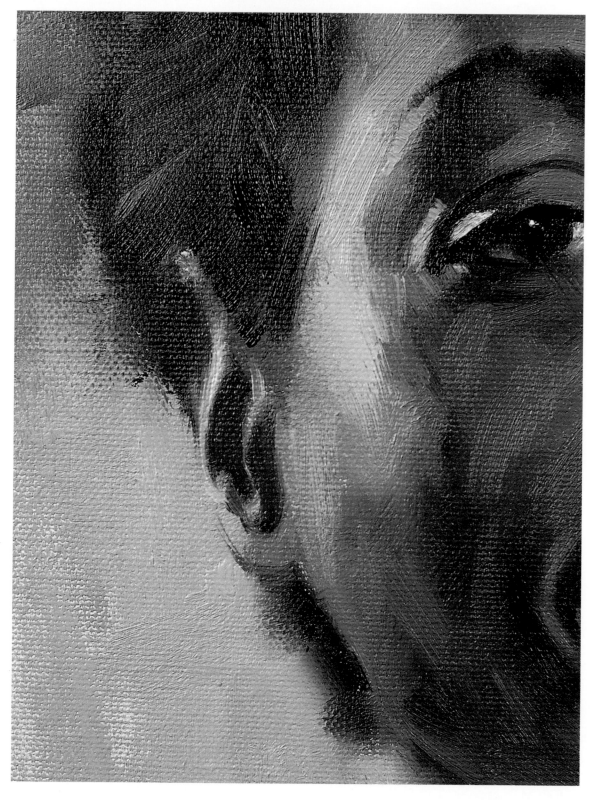

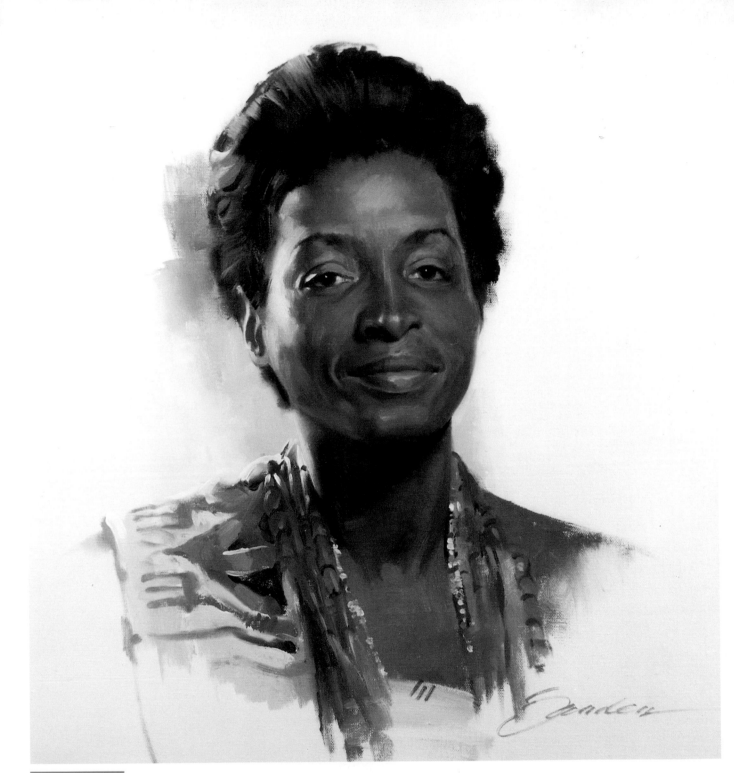

Finishing Touches

Paint the pattern on the garment over the shoulder accurately, though not in a fussy or highly detailed way. Indicate the several strands of beads rather loosely. Each strand has a slightly different coloration; some are reddish, mixed from Venetian Red, and some are more golden, with Yellow Ochre and Burnt Umber as the basic colors. I added a bit of greenish color in the background, using Cadmium Yellow and Ivory Black as my basic colors. Brush the background color into the color of the hair. Add some yellow touches in the background, a bit more detail to the beads and a few more touches on the pattern of the garments.

NIGERIAN LADY (detail)
Oil on canvas, 60" × 70" ((152cm × 178cm)
Private collection

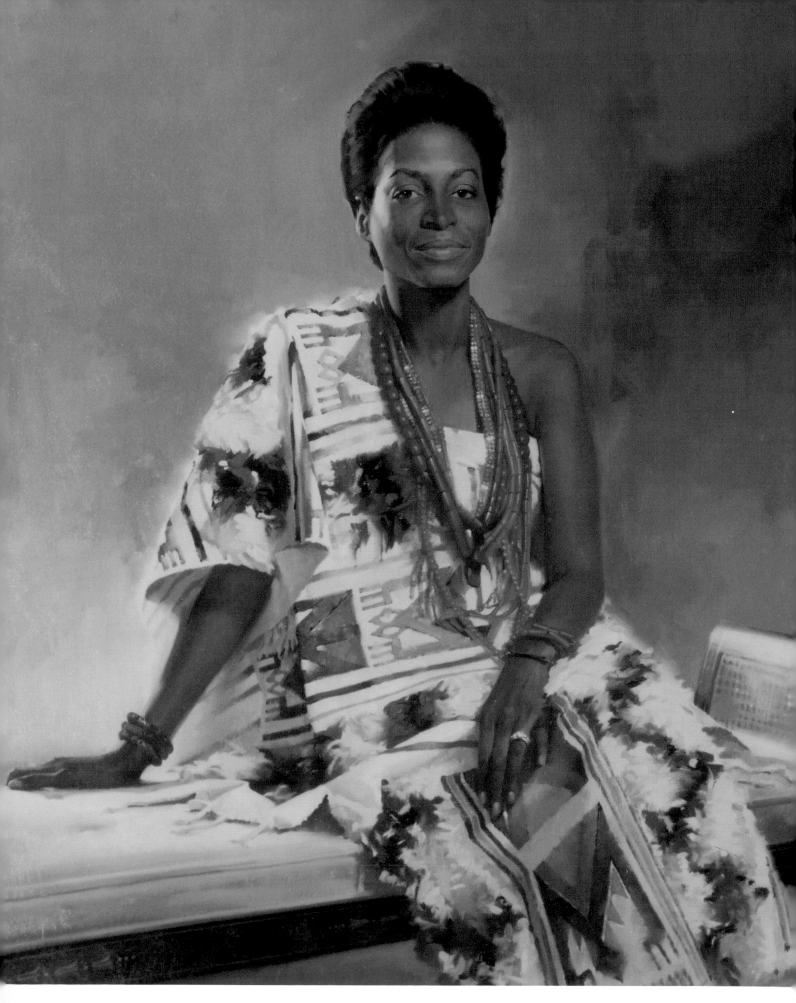

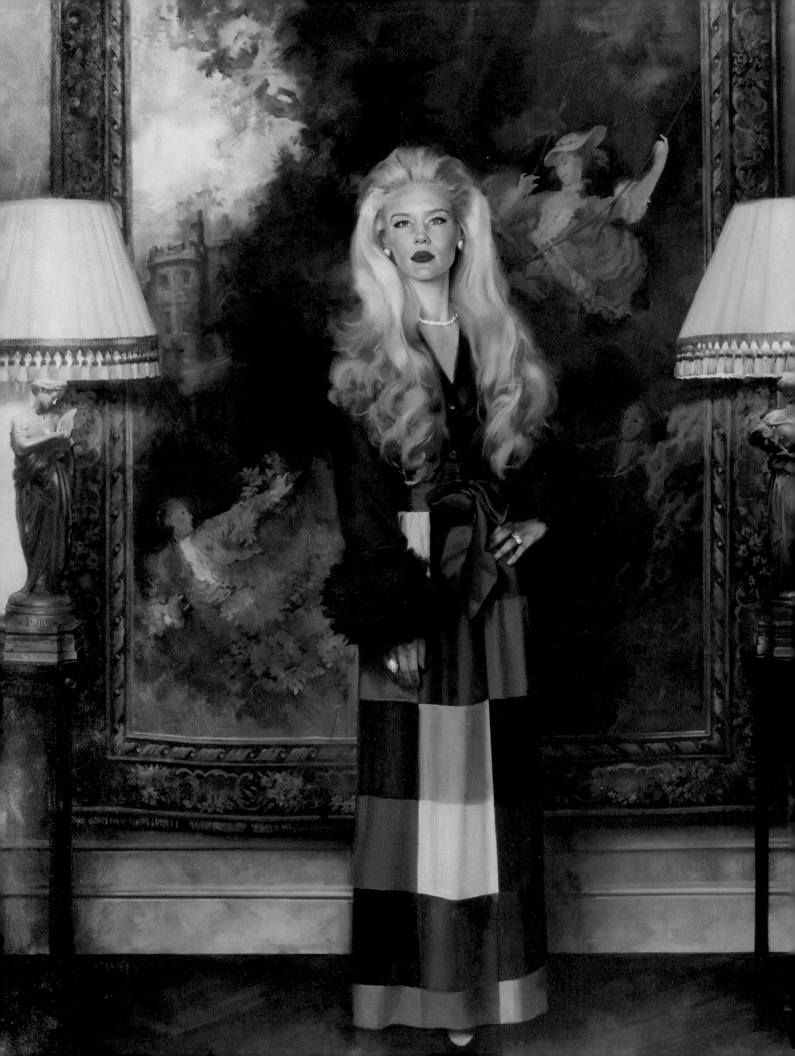

PART FIVE

GALLERY OF COMMISSIONED PORTRAITS

PRIVATELY COMMISSIONED PORTRAIT
Oil on canvas, 70″ × 88″ (178cm × 224cm)

DR. ARTHUR M. PAPPAS

Oil on canvas, 50″×46″ (127cm×117cm)
Collection, University of Massachusetts Medical School
Worcester, Massachusetts

When the Trustees of the University of Massachusetts Medical School decided to name their medical library in honor of their famous chief of orthopedic surgery, they commissioned this painting to hang in the library's foyer. Dr. Pappas is world renowned for his treatment of children with serious orthopedic problems. A routine portrait seemed inadequate. The four children who appear in this painting were being treated by Dr. Pappas at the time the portrait was begun. By the time we had our final sitting (about six months later), all four had been declared fully healed and released.

You will note that even in a complex composition such as this, it is possible to retain a touch of the "vignette" character of many of the demonstration studies in this book.

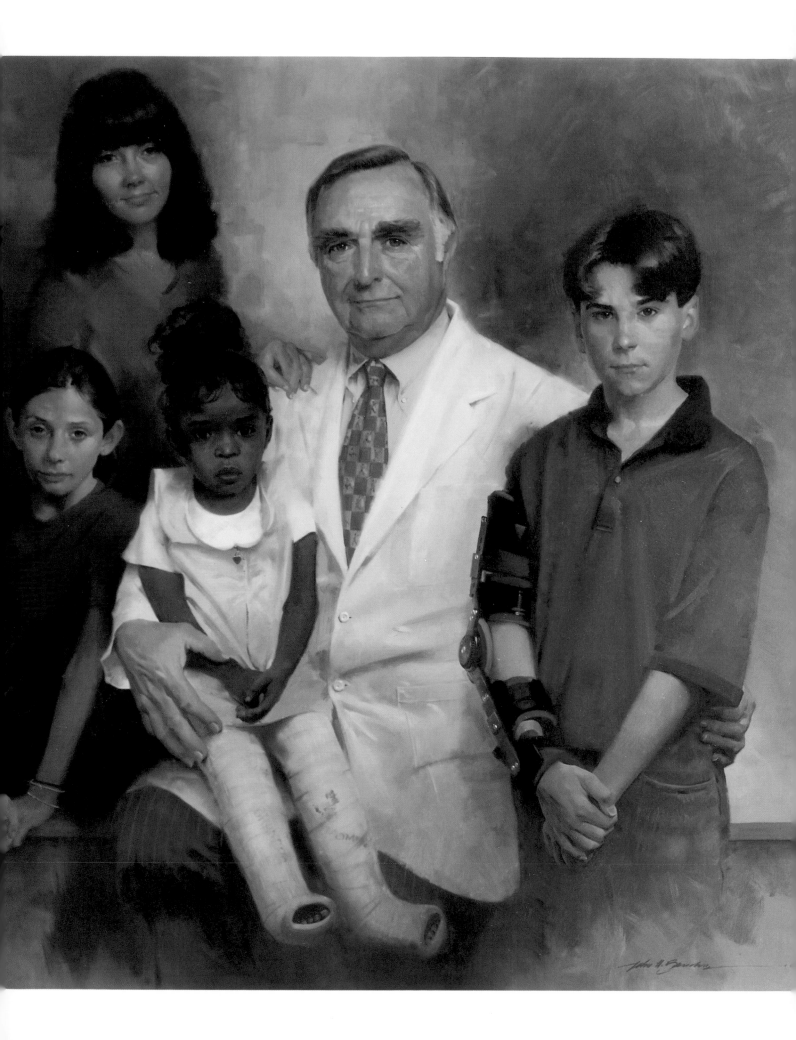

REVEREND BILLY GRAHAM

Oil on canvas, 50″ × 42″ (127cm × 107cm)
Collection, Billy Graham Training Center at the Cove
Asheville, North Carolina

I have been privileged to be associated with the famous evangelist throughout almost my entire life. My father served for many years on the staff of a college of which Dr. Graham was president, and I myself worked as an artist in his organization for a period of nine years. Dr. Graham is a splendid man, and I hope you can sense in this painting my admiration for him and for the cause he serves.

Billy Graham gave me two sittings of two hours each in my studio in New York to begin this painting and, some months later, a final sitting in his office in North Carolina. At the first sitting he seemed somewhat ill at ease and preoccupied, but when he returned two days later, he was relaxed and affable. He sat with great ease on the model stand and reminisced about my father, recalling incidents of nearly forty years before.

God has given Billy Graham many gifts, including a magnificent head and face. As the studio light spilled over his famous features, I worked as best as I could to capture the striking architecture of his face with its resolute strength, recognized by so many the world over.

At the beginning of each sitting, Dr. Graham offered a prayer of encouragement and blessing. What a never-to-be-forgotten experience to have Billy Graham pray for me personally and for the success of the painting!

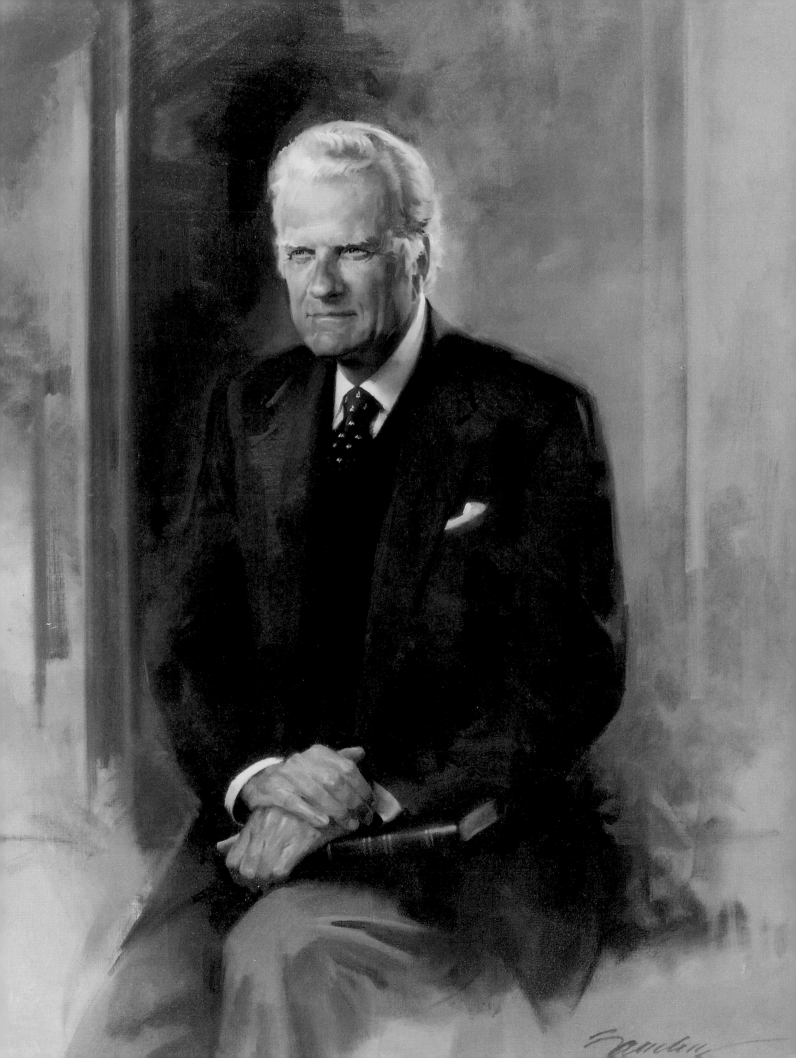

MRS. B.H. HAMLET IV

Oil on canvas, 73″ × 37″ (185cm × 94cm)
Collection, Mr. and Mrs. B.H. Hamlet IV
Bassett, Virginia

The lovely Mrs. Hamlet posed for me on the staircase in her gracious Virginia home. My goal was to keep the composition as simple as possible and to convey this attractive young woman's natural dignity and sense of style. The challenge in a painting like this is to render the setting thoroughly enough to be convincing, yet keep it simple enough that the background doesn't compete with the figure.

I have often felt that over the years I have tended to employ an unnecessarily complex lighting pattern in many of my commissioned portraits. This portrait represents a conscious attempt to keep the lighting as simple as possible, in keeping with the overall quality of the picture.

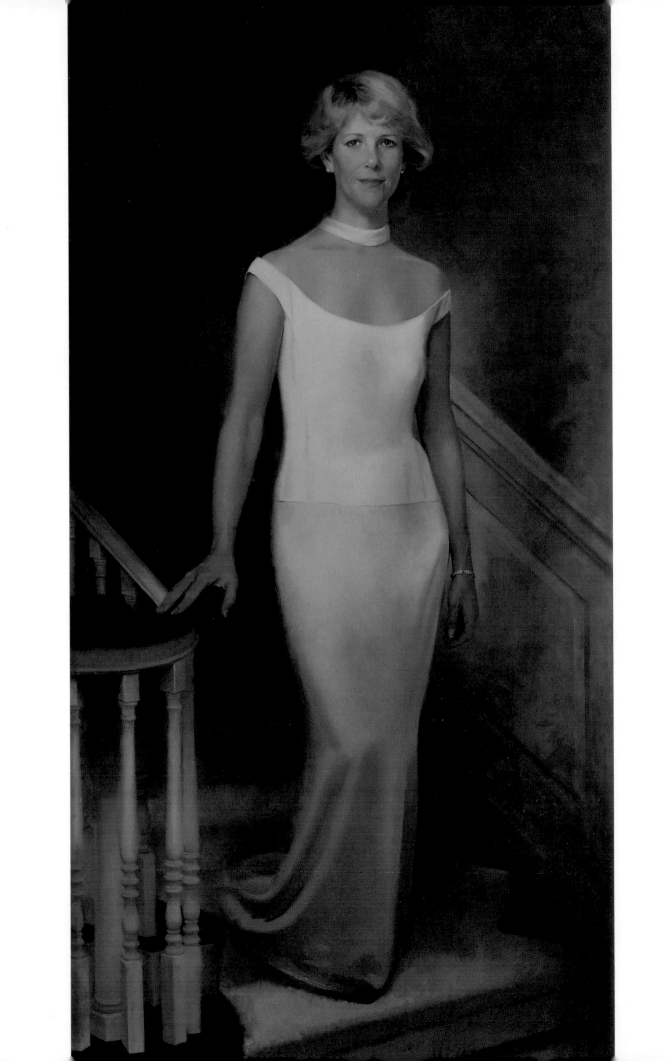

FRANZ V. STONE

Oil on canvas, 50″ × 42″ (127cm × 107cm)
Collection, Mr. and Mrs. Franz V. Stone
East Aurora, New York

The Stones live on a magnificent estate in the beautiful rolling hills south of Buffalo, New York, where they maintain extensive stables of fine horses. Mr. Stone is Master of the Genessee Hunt and is an accomplished horseman and fox hunter. The passing years have not dimmed his love of riding and of the hunt.

Mr. Stone allowed me to paint him exactly as I saw him. He insisted that each detail of the traditional hunt costume be exactly right. When I attempted to subdue the intensity of the yellow vest, painting it a rather pale greyish yellow, he insisted that only a vivid Cadmium Yellow was correct. (I immediately changed it accordingly.)

The highlight on the eyeglass lens is a touch of realism that adds to the believability of the painting.

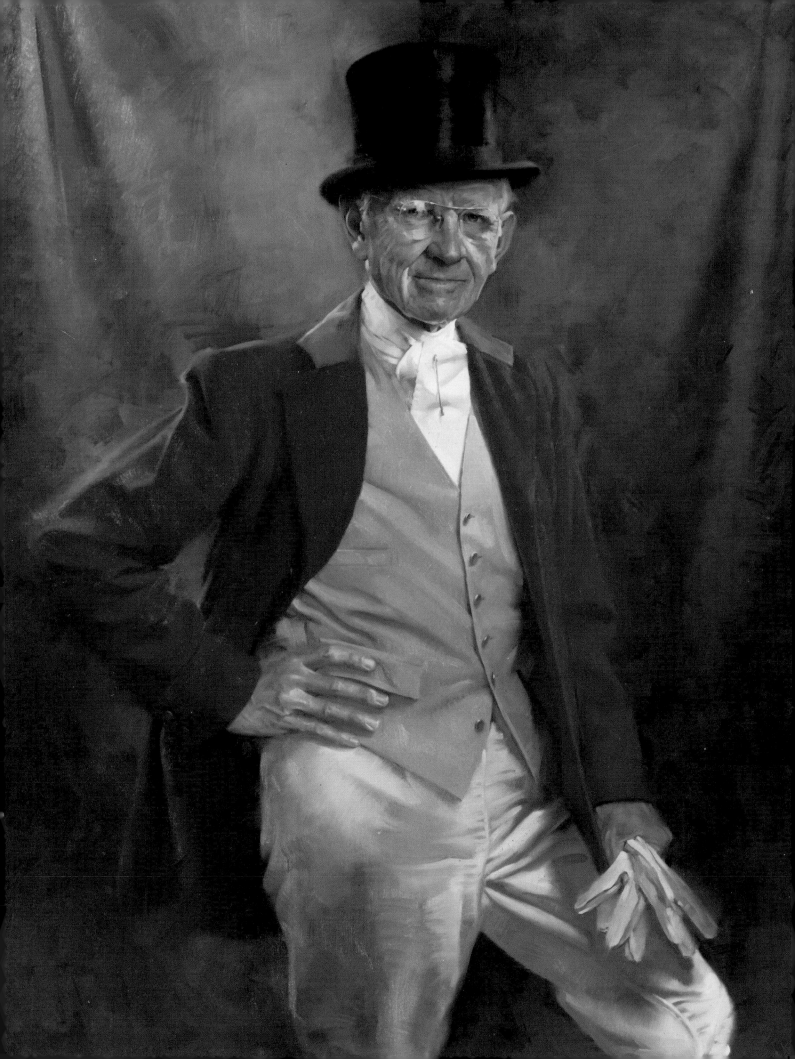

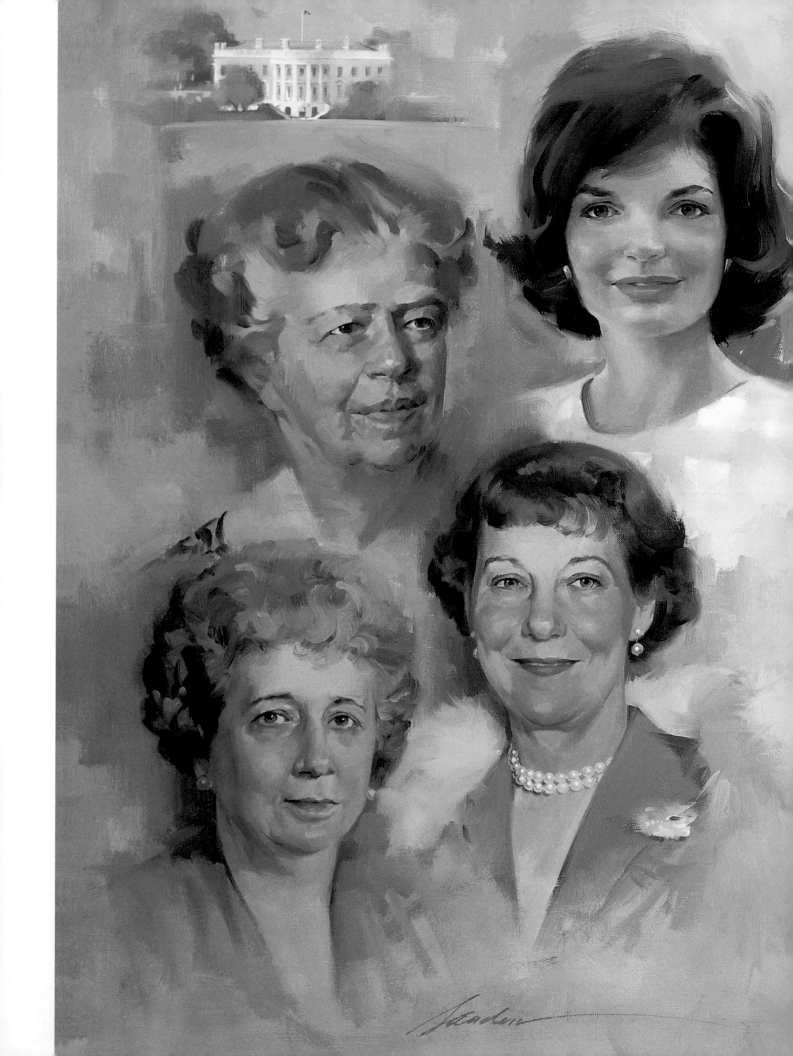

THE FIRST LADIES

Oil on canvas, 40″×30″ (102cm×76cm)
Collection, The Reader's Digest Association
Pleasantville, New York

Publishers are often in need of portraits for their publications. For many years I painted portraits for the Reader's Digest organization, both for their popular monthly magazine and for their condensed book series. This painting was used to illustrate a book entitled *Upstairs at the White House* by J.B. West. The challenge here was to combine historical and contemporary reference material that varied in lighting and color into a cohesive whole. The head of Mrs. Nixon was based on a three-quarter-length portrait of her I had painted earlier.

Index